SHE FOLLOWS
NO PROGRESSION

A Theresa Hak Kyung Cha Reader

Edited by

JUWON JUN AND RACHEL VALINSKY

WENDY'S SUBWAY

CONTENTS

Foreword
SANJANA IYER

Most of Theresa Hak Kyung Cha's published works are out of print. Of the three texts she published with Tanam Press, which she co-founded, only *Dictee* remains in circulation, likely due to its subversive relationship to the novel form. Tanam Press, edited by Reese Williams, printed the first edition in 1982; Wedge Press published a chapter, "Clio History," as a 15.5 by 15.5 cm artist book the same year. Third Woman Press stewarded the second edition in 1994, a year that also saw the release of the volume *Writing Self, Writing Nation: A Collection of Essays on Dictée by Theresa Hak Kyung Cha*, edited by Elaine H. Kim, which propelled the novel into syllabi across the country. *Writing Self, Writing Nation* is famously out of print, as well as Cha's artist book about cinema theory, *Apparatus,* and the collection of artists' writing, *Hotel*, both of which were published by Tanam Press in 1980.

The lifecycle of an artist's book can be capricious. Edition sizes are small; titles go out of print and don't often resurface. Publishing is an act of making public and of transforming what parts of the world are visible. The lineage of small, artist- and activist-run presses that carried the torch of Theresa Hak Kyung Cha's sprawling, complicated legacy, is an inspiration to us at Wendy's Subway. It is with great care that we share this publication with an audience (a word that Cha herself wielded so carefully). All of Cha's work, including her publications, have been diligently preserved in the Berkeley Art Museum's Pacific Film Archives, and consulting their digital catalog has been instrumental to our process. However, criticism and scholarship about her practice is often siloed into academic journals or guarded behind paywalls. Limited access to her work beyond *Dictee*, coupled with her sudden and early death, has overdetermined her biography, casting a shadow of interpretation over her work. She's rarely left to her own devices.

She Follows No Progression encompasses twenty-three contributions by twenty-five artists, writers, and scholars inspired by the legacy of Theresa Hak Kyung Cha. The interdisciplinary patterns that move across this publication honor Cha's steadfast experimentation with genre and form. The reader includes newly commissioned writing that ranges from poetry, to criticism, drawings, and personal narrative. The publication is part of a larger program organized at Wendy's Subway in 2021 and 2022 for the third iteration of The Quick and the Dead series— a curatorial endeavor that examines the life, work, and legacy of a deceased artist in order to draw out their lineage in the present and assemble communities around their work. It is a collective exercise of expanding the topology of their poetic influence. These new contributions consider Cha's unique approach to making art: lingering in ambiguity, in sparse and intentional diction, and attempting to use writing as a way to magnify the slipperiness of time.

What do we lose to time? What do we gain from paying attention to its contours? This project was conceived in 2021, amidst the COVID-19 pandemic, at a time when many of us were preoccupied with the uncertainty of life itself. The speed of the city was slowing down, and the screeching flares of its brakes propelled our reading group to form. We read excerpts from *Dictee* aloud to each other each week, shared overlapping and unfinished bibliographies, and serendipitously renewed our perspectives on unrelated, ongoing projects. Through the practice of reading together and the sporadic unraveling of pandemic time, we developed four seminars and invited facilitators across different disciplines to address each of their themes: "Through the Screen: Mouth to Moving Image"; "Migration and Memory: Embodied Histories"; "Mother Tongues: Between Translation"; "Biomythography: Epic Fabulation, Fragmented Narratives."

Everyone who contributed to this publication spent time *together*. They attended seminars, readings, screenings, and performances, dedicating months to studying Cha and letting her seep into so many corners of life. The constellation of intertextual citations and continued conversations between contributors that carry through this book is a tribute to the new relationships and emergent dialogues built along the way. *She Follows No Progression* echoes some of the best qualities of Cha's writing: her ability to weave disparate genealogies together, manipulating time and space.

Together, we studied what scholar Una Chung, in her seminar, called "the typology of the gap," or in her essay here, the revolutionary power of indeterminacy. Chung reminds us that legibility can easily become a symptom of assimilation.

Together we slowed down time; the recursive gestures of organizing a single seminar, then recording, transcribing, editing, summarizing, and finally sharing its contents set in motion a productive loop of pause and replay. We then organized film screenings, a marathon reading of *Dictee* that coincided with Cha's work on view in the 2022 Whitney Biennial, and a window installation at Printed Matter that centered her contributions to artists' books. Each program emphasized a different point of entry into Cha's multidisciplinary practice, in turn inscribing a new concentric circle to the community being formed around her work at Wendy's Subway during The Quick and the Dead.

The warp and weft of kinship is often an object of critique or estrangement in Cha's work, and though her practice is singular—even lonely at times—she was surrounded by a community of artists, publishers, and friends who supported her work over years, as evidenced by her peers and teachers' recollections in Sujin Lee's video work *Theresa Hak Kyung Cha Project* (2015). Among the many different identities she moved through, Theresa Hak Kyung Cha was also an art worker and editor. She was instrumental to Tanam Press as an editor, worked at the Berkeley Art Museum's Pacific Film Archives for years, and had a brief stint at the Metropolitan Museum of Art in New York. She was both a visionary and deeply attuned to an approach to experimentation that has come to define the era in which she made art. Cha lived through the political unrest of the 1960s and '70s in Berkeley, witnessed the heyday of poststructuralist critique in Paris, and dedicated her life to the study of experimental film history. She also obsessively researched Korean colonial and postcolonial history, bringing it to the forefront of most of her artistic endeavors.

The first encounter with Cha's work can be transformative and revelatory, and many contributors to this collection lead with their own anecdotes of first contact. In *The Book of Na*—published by Wendy's Subway in 2022 amidst this enduring, collective meditation—artist and writer Na Mira shares how they discovered Cha through a photocopied image of the cover of *Dictee* on a cover of a zine by a girl named Yumi Lee from Kansas.

They write:

> I go out and find the book, used, half-off, covered in tombs, death stuttering, spitting, repeating, jagged lineage of martyrs, origin hissing an electromagnetic line not visible, not redaction, empty pages ring at decibel of void, some parts of the text are nothing more than raised flesh, *texere*. Refusal

plays its puncture, the held breath balloons into consciousness, into another animal's verb, talisman not giving but going. i do not understand her as intimately as i do not understand myself.[1]

The fleetingness of "understanding" cuts across all the texts in this collection, perhaps reflecting a desire for the rapprochement between understanding oneself and one another. Poet Brandon Shimoda puts forth "an outline for *future thinking*" and an homage to the epistolary form as one way to understand the grammar of memory. We also see this in Jennifer Kwon Dobbs's letters, in which her committed approach to autobiographical narrative establishes the act of writing as a dialectical engagement between the erasure of the self and its reconstitution. The letter transforms abstraction into intimacy.

The epistolary form is the backbone of *Dictee* and can also be found in nearly all of Cha's work, particularly her significant body of mail art works. In the 1977 artist's book *Audience Distant Relative*, composed of seven sheets of letter-sized paper folded in half to form seven cards, Cha conjures an address: "you are the audience / you are my distant audience / i address you / as i would a distant relative / as if a distant relative / seen only heard only through someone else's description."[2]

In receiving a letter, in being addressed as such, the reader is being hailed. This hail is central to the scholar Soyoung Yoon's analysis of Cha's 1980 artist's book and anthology of film criticism, *Apparatus*. In her seminar at Wendy's Subway, Yoon presented this out-of-print publication to illuminate the connection between Cha's writing and her film and video practice. The publication canonizes a specific turn in film theory post-1968, in which scholars analyzed "film not as just stories that reflect an existing world, but film as a machine, as an apparatus that specifically produces subjectivities." Anton Haugen's essay on *Apparatus* draws inspiration from this seminar and argues that Cha's use of citation destabilizes these pervasive moments of technological interpellation. If ideology is what forces us to turn around and respond to the hail, then Cha's work holds up a mirror to this scene of capture and uses strategies of *détournement* to stare back at empire. Similarly, Irene Hsu's analysis of *Secret Spill* (1974), Cha's experimental film produced six years prior to the publication of *Apparatus*, returns to interpellation by way of Frantz Fanon and grapples with the film's rupturing of sound, language, and body as an allegory for subjectivity produced by colonial violence.

1 Na Mira, *The Book of Na* (New York: Wendy's Subway, 2022), 155.
2 Theresa Hak Kyung Cha, *Audience Distant Relative*, 1977.

Theresa Hak Kyung Cha was in a semiotic arena of her own, transfiguring paper to screen, text to moving image. Her work interrogated what a film "does" to time. In their contributions, both Sam Cha and Jesse Chun approach Cha's film *Mouth to Mouth* (1975) as a durational exercise. Cha lingers on the choreography of enunciation—a kind of aura reading of Korean phonetics. On pages 169 to 186, Chun moves the reader through a still from the film, mouth agape, towards other moments of circularity. The body is both an incarnation and incantation of language. Youna Kwak's nearly-diagrammatic contribution "Homonym ~~Error~~" follows on these heels—an elegy to the performance of dictation.

In *The Monolingualism of the Other* (1996), Jacques Derrida famously writes, "*Je n'ai qu'une langue et ce ne l'est pas la mienne* / I have but one language—yet that language is not mine." The publication first appeared in an abridged form at the 1992 conference "Renvois d'ailleurs/Echoes from Elsewhere," hosted by Édouard Glissant at Louisiana State University, firmly entrenching his arguments in a postcolonial critique. This lesser-known and surprisingly autobiographical text by the elusive theorist warns of linguistic hegemony and the ways in which language simultaneously alienates and connects us. He asks, "How could anyone have a language that is not theirs?"

This very question—reverberating from Glissant's theory of opacity—is pursued by Eunsong Kim in a stunning newly commissioned essay. From Gayatri Spivak's notion of the subaltern to Deleuze and Guattari's contestation of the Hegelian dialectic, Kim skillfully articulates the political stakes of visibility, pointing to the ways in which "individualism as justice is, at best, counter revolutionary." We, as readers and subjects of empire, are not spared of Kim's critique and of her salient analysis of racialization. The political dimensions of Cha's life are set in stark relief by this response to the American regime of far-reaching assimilationism. Kim writes, "Language reminds us again and again: the wound forgets the scar."

Central to Theresa Hak Kyung Cha's practice was the subversion of language and its rules. Artist Sujin Lee writes in her essay, "reading *DICTEE* is an experience in which you discover the gaps and overlaps between you, your language, and your body." Many of the contributors to this publication ruminate on Cha's hypnotic, even hypnagogic, deconstruction of language across form and medium. Six drawings by Andrew Yong Hoon Lee encode the sensation of language by attending to structure, repetition, and space. Translation's role in the undressing of this language elapses in essay and poetry, but also through film and performance (body is language). In an endnote to her Spanish translation of an excerpt from *Dictee*, Valentina Jager writes about the act of translating as ever-unfinished work, "always in transition" and

"continually respoken." Serubiri Moses locates translation across Cha's photographic works, while Caterina Stamou strikes through Greek and English in a new poem inspired by *Audience Distant Relative*. Jesse Chun's aforementioned intervention briefly suspends the dutiful pace of writing to offer the transfiguration of a circle from film still to letter, texture, and sparse poem. Translation here—manipulating shape, language, medium—is iterative, and in each iteration is the possibility of transmutation. Megan Sungyoon asks in her multilingual poem, "What does this matrilineage pass down, from tongue to tongue, that is *not* other to me?"

The title of the last seminar in our series at Wendy's Subway borrowed a neologism from Audre Lorde: biomythography.[3] Writing about oneself can be a process of mythologizing—memory is just as slippery as time. Expanding on the character in development for her 1980 unfinished film *White Dust from Mongolia*, Cha wrote: "She is without Past, her past is speculative, fictitious, or imagined."[4] Jed Munson revisits this film and its mythological relics of storyboards, b-roll, and scripts in his poem "Two Lines / Arc." An encounter with the subjects of Cha's films and writing can evoke a profound sense of haunting. The traces of belonging are long gone. Theresa Hak Kyung Cha revolutionized personal narrative through a constant play of presence and absence, exile and return, first person becoming omniscient. She laid bare how history is alienating yet embodied. In Juwon Jun's "On Stones," the reader moves through a narration of childhood in which memory gains visceral texture, running up and down the spine. Jun writes, "Each day they scrape against our inners and soften their edges. They roll around and push through our skin, insist that we are porous. We no longer recognize the form. They polish and harden into a reminder." These sometimes-unforgiving reminders of where we come from—the links between personal and collective memory—take shape through the act of writing. Or, in other words, writing is a looping, physical act of remembrance.

Several contributions to this publication take up the exercise of reconstructing memory by way of migration, diaspora, and "the prosthesis of origin." Victoria Pitaktong's essay memorializes conversations with her father and how to "listen beyond words." Jennifer Gayoung Lee levels a critique of imperialism and the nation state in describing her experience as a second-generation Korean American learning her mother tongue. By examining the role of martyrs in *Dictee* alongside a left internationalist struggle, Youbin Kang proposes a connection between revolutionary

3 Audre Lorde, *Zami: A New Spelling of My Name: A Biomythography* (Berkeley: Crossing Press, 1982).

4 Theresa Hak Kyung Cha, *White Dust from Mongolia*, original script for unfinished film, 1980.

and mystical spirit. Reminiscent of *Audience Distant Relative*, Florence Li and Marian Chudnovsky's collaborative essay destabilizes voice and subject, leaving the reader with treasured fragments of anamnesis. Sifting through these writings, moving through different formats and subject matter, is like reading Theresa Hak Kyung Cha as a state of mind "just to keep the void out."[5] She moves like a shadow across every page. Grief is a throughline when thinking about Cha, demanding a reflection on the spectacle of violence. Her senseless murder often obscures the vitality of her life and manipulates her legacy with the twinge of true crime. In this program series, it felt crucial to carve out space for mourning while extending a politics of remembrance. In Teline Trần and Yves Tong Nguyen's transcribed conversation, new definitions of "memorial" take shape. The two discuss the slipperiness of carceral logic when confronting loss and the ways in which sweeping generalizations about Asian American identity make marginality legible to the US imperialist state. The conversation offers a critique of legibility, linking contemporary struggles with the disentangling of memory. How do we remember Theresa Hak Kyung Cha for who she was, not who we want her to be?

I wrote this introduction on the evening of the summer solstice—the subtle auspiciousness of the longest day of the year. Exactly two weeks ago, the sky in New York City was a burnt dense orange from wildfire smoke and tomorrow begins the edge of a new tropical storm that threatens to flood the city. If I've learned anything from Theresa Hak Kyung Cha, it is that we are sieves of time. Steeping in her work is an antidote to the relentless violence of everyday life. It requires us to slow down, to pay attention to the way our mouth contorts words. She dissolved the boundaries between genres: a letter was a film and a film was a poem. As an organization, we learned to apply her visionary way of thinking to our own collaborative practice. It was a lesson of research, patience, and minding the gap. I'm grateful to everyone who joined the many ways we gathered around Theresa Hak Kyung Cha for over a year. This publication is a testament to her enduring influence on artists and writers today.

5 Theresa Hak Kyung Cha, *Exilée and Temps Morts: Selected Works* (Berkeley: University of California Press, 2022), 143.

Editors' Note
JUWON JUN AND
RACHEL VALINSKY

She Follows No Progression: A Theresa Hak Kyung Cha Reader takes its title from an excerpt of *Dictee* where a nondescript *she* is observed in an empty theater. The text recounts her seated at the cinema, suspended between the darkness and the vastness of the screen. Observation quickly turns inwards, towards a space withheld from time and memory:

> She follows no progression in particular of the narrative but submits only to the timelessness created in her body. (Ancient. Refusing banishment. Refusing to die, the already faded image. Its decay and dismemberment rendering more provocative the absence.) She remains for the effect induced in her, fulfilled in the losing of herself repeatedly to memory and simultaneously its opposition, the arrestation of memory in oblivion. (regardless. Over and over. Again. For the time. For the time being.)[1]

Much cinema traffics in narrative: through the progression of plot and the presumption of causality, through visual tropes that lend psychological depth to "characters," through the projective mechanisms that produce viewer (dis)identification. Against the narratives carried by the screen, and perhaps, against the purported linearity we find also in literature, in the telling of history—all of which Cha repeatedly refuses to submit to throughout her writing—the unnamed she is seen to be arrested by her own feeling, preoccupied by what concerns her body. She is located in the embodiment that language only ever, and ever so inexhaustibly, allows us to glimpse. Through language—between parentheses, in letterforms that a period cleaves or apposes—and in the spaces that are never only gaps, but also

1 Theresa Hak Kyung Cha, *Dictee* (Berkeley: University of California Press, 2001), 149–50.

JUWON JUN AND RACHEL VALINSKY

resonant and replete spaces and silences—there is a priority of feeling. A shedding of the logic that governs the tongue, the body, the many lives lived under colonization. A return to what exists before memory, before the inscription of language and the loss of time. From this passage, for which Cha offers the title, "Memory," we draw a vision we carry forward into the collection of texts and artworks assembled in this book—a vision that hovers between darkness and expanse, between absence and presence, between resolve to remain and the entropic pull of oblivion. What surfaces is dissent from what is given to us as truth; an outline for how we may begin to imagine ourselves differently against the current of colonial forms; and a renewed attention to how we touch, feel, speak, and think through our bodies and in relation.

She Follows No Progression is a collection of works unruly and singular in their criticism, testimony, and form. Each engagement sustained in a text or elaborated in visual form, evinces a relation to Theresa Hak Kyung Cha—her life, her work—that is at times personal and troubling, unresolved often, yet undeniably formative to the subjects at hand. Invoking in a vast constellation of subjects and genres, from the familial (friendship, death, family, genealogy), to the literary (memory, language, translation), the visual (performance, film, and video), the political (race, gender, empire, mythology, colonialism, revolution, trauma, history), they animate the subjects present in Cha's own body of work into a dialogue. Eschewing anything so much as "progression," the book is nevertheless loosely ordered by sections of contributions that resonate together and paced by the sonic drawings of Andrew Yong Hoon Lee. A first grouping cues us into an epistolary position—from the I to you—as the knot formed by the mother tongue, language, nationality, identity, and the familial come into view. Experiments in language and translation unravel such concerns and present new questions, shifting to the conditions that enable such entanglements—how they are foremost a question of politics, a symptom of the colonial present. We move toward the materiality of the book, of the screen, arriving at Cha's moving-image work, and to the life of the object burdened by history. As we crawl out of the screen to the dirt of the earth, we are finally greeted by other stories, memories that echo past the confines of the present.

Though there is no progression, there is infinite movement. What has concerned Cha continues to agitate, move, and shape us, as attested to by the voices gathered here. Language was most importantly a medium for Cha—a space in which the self is undone and rewritten through undoing word itself. Cutting up words until they become matter, only sound. In the debris of language, she looked for herself. In what she left behind, we look for ourselves once more. There is no order, only

movement away from what keeps us stagnant. This is a collection of works restlessly in motion, in relation, gravitating toward and away from each other. From all directions, we return to word. As Cha writes: "She returns to word, its silence."[2]

2 Cha, 151.

Liquids and Phonemes
ANDREW YONG HOON LEE

Sometimes, the lines that have accumulated into a form look back at you.

*

The space is arrested with both the past and the present.

*

Language moves within the line.

Liquids and Phonemes is a series of drawings on paper interspersed throughout this volume.

Each of the six drawings reproduced here marks a pause or passage between sections of the book.

You write you / I write you
an outline for future thinking
BRANDON SHIMODA

It was a long time before I realized that a book could be written by someone who was not dead. It is not that I thought books were written *by* the dead—although some part of me thought that. But I thought that writing was what took place while the writer was alive, while a book was what took place—*and took the writer's place*—after they died. This was, when I was young, my understanding of books, of writers, and of writing. I am not sure when I stopped thinking this, or if I have.

I dedicate the above paragraph to my friend, the poet and translator Youna Kwak. Youna and I were talking recently about Theresa Hak Kyung Cha. We were trying to remember when we first encountered her. Cha's work, especially her book *Dictee*, changed our relationships to reading and to writing and remade our relationships to Asian diasporic and Asian American art, but neither of us could remember.

The following are notes on *Dictee*, mostly related to the "Calliope Epic Poetry" section, and mostly related to the epistolary. Epistolary refers, conventionally, to letter writing, but its etymology is to send news, so there could or should be a more capacious conception of the epistolary in terms of what it creates in time and space, of what it means *to send,* and of the meaning of *news.* These are notes on their way to becoming thoughts. In other words, this is an outline for *future thinking.*

The epistolary is the imagination of a face which exists in a future towards which the writer projects herself. But, like a star that can only be seen by looking at *the emptiness* that surrounds it, the face is inaccessible, manifested instead by the emptiness. The tension between wanting to see the face and not being able to see the face is memory. Tension. A tension. Attention. Memory is a structure of survival. *Surviving is predicated on death,* said Youna Kwak in an interview about her book, *sur vie. To feel the emanation of the sur in survival,* she says, *is to maintain our rightful proximity to*

the dead.[1] Survival is a mounting and is amounting, the sublimation of the paroxysms of the dead into something like an event horizon. The dead are the most convincing argument that the most enduring relationships, including the most compromised and precarious, do not exist in time or space, but in distance and displacement. Memory is generated out of displacement—rupture, separation, erasure, loss—and is the consciousness not of place but of placelessness. Place is already a series of displacements, against or inside of which forms of transmission and presence— storytelling, for example—generate the means of endurance. Memory and the epistolary are forms of storytelling in which the self is emptied into a void. *Must break. Must void*, Cha writes, at the beginning of *Dictée*.[2] The void is generative. As Elaine Kim writes in her essay, "Poised on the In-between: A Korean American's Reflections on Theresa Hak Kyung Cha's *Dictee*," *by changing "void" from a noun to a verb, Cha transforms the passive and receptive into the active and explosive.*[3]

To explode is to expel, violently. The void appears in the Taoist cosmogonic chart on page 154 of *Dictee* in the form of a numbered list outlining, in Chinese characters, the origin of the universe. Number 1: *Taiji*, which translates to "The Great Ultimate" —the state of oneness before differentiation, the source, simultaneously, of one's origin and destination.

The vast ambiant sound hiss between the invisible line distance that this line connects the void and space surrounding entering and exiting, writes Cha.[4]

"Calliope Epic Poetry" is a rewriting of epic poetry, its being turned over to reveal the subject it traditionally erases. Instead of narrativizing power, it brings us into the consciousness of subjection, of those emplaced and displaced by power, and therefore into matrilineal counter-narration. The subject of epic poetry, as Simone Weil writes in "The Iliad, or, the Poem of Force," is force—*force employed by man, force that enslaves man, force before which man's flesh shrinks away.*[5] The narrative of nation-

1 Youna Kwak, interview by Joseph Spece, *Sharkpack Poetry Review*, March 3, 2020, sharkpackpoetry.com/2020/03/03/an-interview-with-youna-kwak/.

2 Theresa Hak Kyung Cha, *Dictee* (Berkeley: University of California Press, 2001). All the excerpts from *Dictee* included in this text share this citation.

3 Elaine H. Kim, "Poised on the In-Between: A Korean American's Reflections on Theresa Hak Kyung Cha's *Dictée*," in *Writing Self, Writing Nation: A Collection of Essays on Dictée,* ed. Norma Alarcon and Elaine H. Kim (Berkeley: Third World Press, 1994), 18.

4 Cha, 56.

5 Simone Weil, "The Iliad, Or the Poem of Force," trans. Mary McCarthy, *Chicago Review* 18, no. 2 (1965): 6.

building masquerading as self-determination, epic poetry converts—and revels in the conversion of—human beings into things, intimacies into abstractions, while the epistolary converts abstractions into intimacies, which requires the inventive empathy of the writer and the empathetic invention, by the writer, of the other.

Mother, you are eighteen years old, Cha writes, at the beginning of "Calliope Epic Poetry," in an address that reanimates a time before Cha was born.[6] Her mother, Hyung Soon Huo, lives in a village in Manchuria with other *Refugees. Immigrants. Exiles.* Her mother tongue, Korean, is forbidden, forced to become a refuge. From the Old French "hiding place," from the Latin "to flee back." *It is being home,* Cha writes. *Being who you are,* which means, given the conditions into which her mother has been forced, *fleeing back to a hiding place.* Hyung Soon Huo returns, in the dark, in secret, to her mother tongue. She returns home, to her mother, *inseparable from which is her identity, her presence,* Cha writes. Cha, meanwhile, returns to her mother's illness; she returns to a dream her mother had when she was ill, a dream both *memoryless and dreamless,* filled with women dressed in *strange and beautiful cloth, carried in a light breeze faintly lifting above ground as if their bodies wore wings,* Cha writes.[7]

In her performance piece *A BLE W AIL,* she hung between herself and the audience a cloth curtain which she described as an *opaque transparency. In this piece,* she wrote, *I want to be the dream of the audience.*[8]

She returns her mother, at the end of her mother's dream, to her mother's mother, who holds her hand and watches her daughter, Cha's mother, dreaming, die into her.

To search is to affirm and enliven a kinship deadened by forced removal, concealment and forbidding, writes Jennifer Kwon Dobbs in *Notes from a Missing Person. Whether one reunites or not, one transgresses by way of the dream.*[9]

I am holding two strings at the same time, said E.J. Koh in an interview about her book, *The Magical Language of Others.* One is the mother who delivered her child, she says. The other is the child who can deliver her mother.[10]

6 Cha, 45.

7 Cha, 51.

8 Theresa Hak Kyung Cha, quoted in *The Dream of the Audience: Theresa Hak Kyung Cha (1951–1982),* ed. Constance Lewallen (Berkeley: University of California Press, 2001), 3.

9 Jennifer Kwon Dobbs, *Notes from a Missing Person* (Buffalo, NY: Essay Press, 2015), v.

10 Ruwa Alhayek, "Writer and Translator E.J. Koh Explores the Bridged and Braided Histories of Language," *Asymptote Journal,* August 23, 2021, asymptotejournal.com/blog/2021/08/23/writer-and-translator-e-j-koh-explores-the-bridged-and-braided-histories-of-language/.

In *Minor Feelings*, Cathy Park Hong writes that when Cha's mother read *Dictee*, *she had to stop a number of times because she felt that Cha was speaking directly to her.*[11]

"Calliope Epic Poetry" is based, in part, on the journals that Cha's mother, Hyung Soon Huo, kept in Manchuria. In her essay, "The 'Liberatory Voice' of *Dictée*," Laura Hyun Yi Kang references the journal's *transgenerational and transcontinental survival,* which could be synonymous with a form of migration that does not end, but transforms, indefinitely, becoming Möbius, without beginning or end, but holding, in its center, a precarious circle.[12]

What if, instead of being attached to and reconstituting a place in one's past, memory anticipates a place in one's future, in which the displacements through which the *Refugees. Immigrants. Exiles.* have been forced are resolved in a kind of paradoxically halcyon space that is the consummation of a home that is at once original and not yet come to term? *Like birth like death*, Cha writes. *Unlike birth, unlike death*, she writes, one line later.[13]

Calliope, the Muse of epic poetry, is the mother of Orpheus, who famously looked back to confirm a face—the face of Eurydice—which resulted in her being banished to the underworld, as if the underworld were that much different, systemically, from the world she would have had to endure if her tedious, insecure lover had not lost faith, or rather, control. Eurydice is bound by a lack of choice between worlds in which her life and death are dictated by men, both of whose priority is surveillance, keeping their subjects in view.

A few years after becoming a US citizen, Cha returned to Korea to make a film, *White Dust from Mongolia*. Her experience was that of feeling dismissed, re/alienated. Citizenship, the imprimatur of the nation-state, replaces existence with proof of existence, *effacing* the *Refugees. Immigrants. Exiles.*, replacing their face with the fetish of legibility behind which the individual disappears. *Somewhere someone has taken my identity and replaced it with their photograph*, Cha writes.[14] As Grace M. Cho writes in *Haunting the Korean Diaspora*, those who have been born from the US-Korea relation-

11 Cathy Park Hong, *Minor Feelings: An Asian American Reckoning* (New York: One World, 2020), 164.

12 Laura Hyun Yi Kang, "The 'Liberatory Voice' of *Dictée*," in *Writing Self, Writing Nation: A Collection of Essays on Dictée*, ed. Norma Alarcon and Elaine H. Kim (Berkeley: Third World Press, 1994), 82.

13 Cha, 145.

14 Cha, 56.

ship *are not the living proof of harmony across lines of difference* as much as they are *bodies bearing the marks of militarization.*[15] *White Dust from Mongolia* remained unfinished at the time of her murder.

Fifteen years later, Hyung Soon Huo published a collection of essays in Korea about her life, including her daughter's death. It is currently being translated into English. I imagine that she, as her daughter before her, returned to her journals to reconstitute a life—as *Refugees. Immigrants. Exiles.*—that was both distant and not yet realized. I imagine them staring together into the journals and seeing each other, in that moment of research and divination, unsettled in place and in presence, then falling through the face of that desire.

Face to face with memory, it misses, writes Cha, at the end of "Clio History."[16]

Is the existence of a book the consequence of watching one's mother write in her journal then watching her stop writing in her journal and hide the journal away? Is it the attempt to recover the imagination of the space that had to be willed into creation on the underside of violent delimitation, and the imagination, in that precarity, of what was written, including what was not, and where it went, energetically speaking? It does not stop moving. There is no recovery. But return. *She returns to word,* Cha writes. *She returns to word its silence. If only once. Once inside. Moving.*[17]

15 Grace M. Cho, *Haunting the Korean Diaspora: Shame, Secrecy, and the Forgotten War* (Minneapolis: University of Minnesota Press, 2008), 23.

16 Cha, 37.

17 Ibid., 151.

Diseuse in a Dead Time:
Letters to Theresa Hak Kyung Cha
JENNIFER KWON DOBBS

Dead time. Hollow depression interred invalid
to resurgence, resistant to memory. Waits. Apel.
Apellation. Excavation. Let the one who is diseuse.
Diseuse de bonne aventure. Let her call forth.
Let her break open the spell cast upon timeupon
time again and again. With her voice,

— Theresa Hak Kyung Cha, *Dictee*

LETTER #1

Dear Cha Seonsaengnim,

The poet Lynn Emanuel suggested that I read *Dictee* in 1997, fifteen years after its initial publication by Tanam Press. I was living alone in Pittsburgh and shuttling aboard the 71C between Shadyside and the Cathedral of Learning's fifth floor. In Lynn's graduate workshop, I had begun to sign "Jennifer Kwon Dobbs" on my peer feedback letters. I no longer wanted to pass as a white woman on the page, but to my adoptee ear, plugged with US English, my Korean name Young Mee felt like a broken gesture vulnerable to white ridicule: an Asian woman in her early twenties pointing at her flat chest announcing "Me young. Young Mee." Kwon had no English-language cognate. Kwon felt abstract, had weight and assonance beside Dobbs.

Kwon marked difference.

Yet after reuniting with my omma and appa in 2011, following a thirteen-year transnational search for my Korean family, I learned that social workers randomly selected names like Kim "Better Luck" or Yoon "Lost Twig" as a bureaucratic step to request an orphan visa.

Kwon marked the subject for removal.

Reading *Dictee*, I have always been struck by how you approach language as a re-mark that cuts into a surface at the moment of utterance. The apparatus of the mouth, tongue, and jaw. The flipbooks of eyes blinking. The frontispiece. A photocopy of coal miners' messages carved into the colonizer's darkness—gohyang eh gagoshipda, baegopa, bogoshipa omoni—scratches that a non-Korean-reading audience may take as marked evidence of the image copied from the image copied from the image copied again and again pressed against the machine's glass. I am surely approximating, Cha Seonsaengnim, while I respond to your writing with the weight of my body—a document that bears little resemblance to yours.

Kwon as a marking, as a laceration of the page, a severance to distinguish the Republic of Korea from a material to be re-marked, to be marked, to again in utterance be at removal.

Kwon marks the audience at a removal.

연탄불 피우면서 살아서요

burning
coal

40

Brother's name

제 훈
아 우 제 공 훈

你養活 飮빼
8

져0ㄷ

財 勛 勳

나의 성 (이) 李 米 㤗眞

수 진

빠의 성 → (허)

서초동

물(수) 복받을(진)

서울 친구집 깨끗함 아름다운

훈 (마음)

When my mother nursed me
she named me soojin.

~~She named my brother~~
~~훈 but my father~~

changed his name to 득상
@ KSS when he was
surrendered for adoption.

재훈 = mother's grandfather
★ named him.

지훈 = omma when
in 오랑진

LETTER #2

In your NEA grant application's summary of work, you write you're "looking for the roots of the language before it is born on the tip of the tongue."

Steel wool packs my mouth, scrapes my tongue stiffened by English.

I read *Dictee* with irritation. My gums bleed.

Cathy Park Hong writes, "The critic, schooled in the post-structural pieties of separating text from author, has been careful to emphasize that *Dictee* is a rejection of autobiography, a manuscript of missives washed up on the shore for her dissection."

Like Park Hong, I'm disturbed by your body's absence in the literature about your art and understand this disembodiment as a process of canonization.

Yet the saints who you illuminate are women who gave their bodies to revolution:

> *She calls the name Jeanne d'Arc three times.*
> *She calls the name Ahn Joon Kun five times.*
>
> *There is no people without a nation, no people without ancestry,*
> you remark.

She who is without nation, without ancestry. Re-marked, always at removal, not born on the tips of the people's tongues who have nation who have ancestry.

A death who is not dead.

How to call her forth inside of time?

Previous page: Jennifer Kwon Dobbs journal, digital reproduction.

DISEUSE IN A DEAD TIME

"Viewing a Picture of Her New Family," digital reproduction from *Stars and Stripes,* Korean War Children's Memorial, Bellingham, Washington.

LETTER #3

Dear Cha Seonsaengnim,

I confess I misread *diseuse* as disuse and am ashamed of my limbs, my grunts and groans, translation apps, my novice and intermediate, this circuit board firing up strange operations:

Ayuda me dopda.

Je pense uri gohyang eh wonju retourner.

파란색, vert sec, grün sec

Essen gaja

The code sticks. Kill switch.

The activated bits smolder:

With a vocal range of four notes, Yvette Guilbert was determined to become a singer. Born in Paris in 1865 to a father who gambled away all that he earned, she worked alongside her mother doing millinery and beadwork. Singing in the Moulin Rouge's café-concerts scene promised more money, but she was dismayed by the coarseness and vulgarities expected of the performers to titillate the drunken crowds.

Across the cabaret's smoky plumage, a monochrome resolves not to move. Diseuse.

Yvette enters the stage, sings her first song, and is promptly forced to leave as the audience heckles her mercilessly. Trying to come back on, the howls of disapproval are so intense they have to lower the curtain. She leaves after five days into her ten-day engagement; the audience refuses to hear her, and roars with dismay the moment she steps on stage.

They slap the tables. They slap their thighs. They slap the air.

The waitress arrives to take my order. My face resembles a younger sister, but when I speak, metal grinds metal. Because she remembers living in an occupied country, she trusts her ears to detect an intrusion. She sees.

Chalot, *Melle. Yvette Guilbert*, ca. 1890–1934,
photographic print on card mount, 17 × 11 cm (mount).

JENNIFER KWON DOBBS 49

She hears:

>Yukaejang hanago bap dugaeyo.
>Dohaneun, boricha issayo?

To a white person watching, the waitress is correcting me, but they are wrong. This is an intimacy: her lips pummel each syllable yu-kae-jang yu-kae-jang, her tongue a mallet against a cymbal, to clear the offending air between us.

I refuse to disappear: "My omma lives in Daegu, and my appa lives in Seoul. It's not my fault that my parents are divorced, ajumoni." She whispers ajumoni taking it into her mouth, tasting it. The taste of my omma and appa, the taste of me.

I'm lying, yet as "a child of divorce," I pass. She passes to the next table. The customers look around titillated by what they witnessed. She takes their orders.

Diseuse / disuse:

>Gago essen. Baegopa.
>Can you voire omma ddal?

"Maybe he's kimbap? White rice on the inside, Korean on the outside."

LETTER #4

Dear Cha Seonsaengnim,

The audience shuffles into a surgical theater, stores their leather attachés underneath the seats, grant applications already scored. Their heads cock to one side and slowly move back and forth keeping time, observing:

> Can she use details? The copper wire and silver mesh? Can she vivisect
> the heart separated from the gray parts to describe the craft that makes
> the death not dead speak?

The flat tongue lolls to the left, not used to this redirected blood flow by any means necessary these experiments that must be public to be believed. I take the organ apart like your student, Cha Seonsaengnim. I jolt and fire up a nerve net. I stimulate the audience. Their heads still; time stops. I write down last century and understand this mirroring as part of an architecture. The mirror above the death not dead enables the audience to look more closely without shame.

The white audience wants to overlay your body over my body over the cadaver over and over. Using and using. I tire of denying your influence on my art for fear of misuse.

I have tried interruption. Slowing time to a still held up to a red bulb inside a dark room. Each gesture cared for. The position of the mouth. The point of the tongue. Before the phoneme escapes the cave and interior shaft of the throat. What residue from a time un-marked? The critics tell me there is no retrieval. I am not interested in the sentimental.

Here are my four notes where the knife licked bone.

LETTER #5

The horror is not the erasure, but the illegibility alone in a white space:

When the French novelist grabbed my waist while we danced at the festival party and said, "Pretend I'm your adoptive father."

When the editor put his hand on my thigh inside the cab and told me his adopted Chinese granddaughter's name.

When the tenure-track job candidate thanked me for guiding him to the interview room and asked if we could find a moment alone because his first wife was Japanese.

When R. Leathers raped me and said he wanted to be my first.

When the ajossi behind the store counter glared at me mistaking my white father for my lover.

Left: Jennifer Kwon Dobbs, *Untitled*, 1979, photograph.
Personal Collection, Saint Paul, Minnesota.

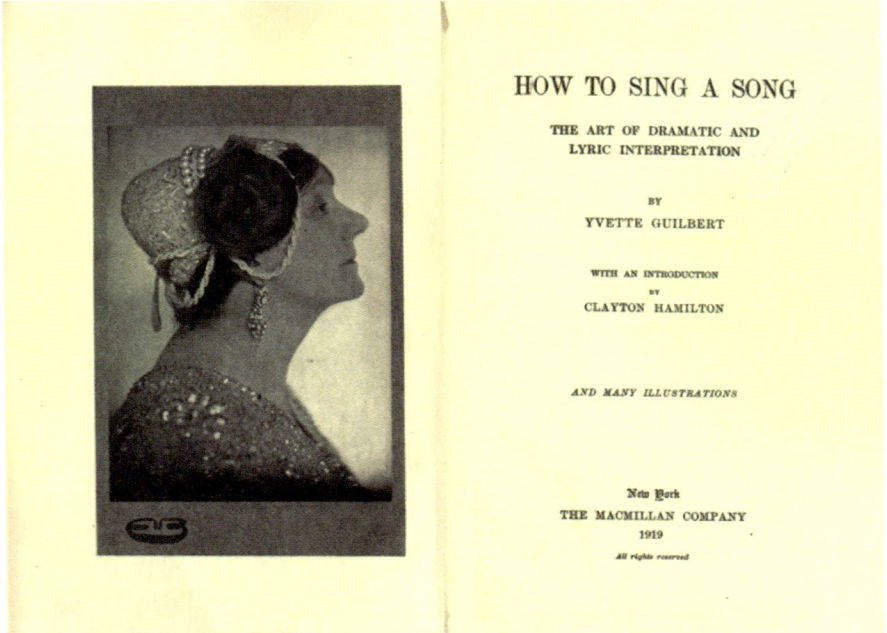

Yvette Guilbert, *How to Sing a Song: The Art of Dramatic and Lyric Interpretation* (New York: Macmillan, 1919).

Dear Cha Seonsaengnim,

November 5, 1982. You carry a red satchel and wear a beret and gloves. Chuwoyo. Il froid en New York.

> *Yvette Guilbert found a small book at a booksellers' stall, titled* Les Chansons sans-gène, *by Léon Xanrof, a Parisian humorist, playwright, and songwriter. It contained enthralling verses with ironic descriptions of the Parisian student life embodied at the Parisian cabarets. Yvette knew she had found her repertoire, and she lucked into an engagement at the Liège. The songs she chose, including the iconic "Le Fiacre," "L'hôtel du numéro trois," and "De Profundis" were promptly scored and learned along with an arrangement of her own poem, "La Pocharde." She brought down the house that evening at the Liège. The audience demanded ten curtain calls.*

I am searching for your writing, all out-of-print except for *Dictee*. Yet there are international exhibitions, biennials, magazine special issues, and community spaces remembering your oeuvre and acknowledging your influence. Your after-lives and audiences.

If the audience is a relative, as you say, then I want to account for my silence: It hurts to repeat how you died when how you thought about language has enlivened my dead, violated parts for which I have felt so much shame.

Je ne peux pas.

Any resemblance is a mistake, a mispronunciation or misreading, for we are not kin just as you are not Yoko Ono, and I am not Connie Chung!

In relation, connaitre or savoir -yo or -hae as in saranghaeyo or saranghae as in I am familiar por ejemplo I am a familiar, attend, attendre to wait at the moment of a removal, of 외상

to spell 외상 as 외 and 상

beside or outside song, prize, song

to dispel, to take back that instance, a blast of New York wind knocking your beret down the subway stairs, your red satchel lost on the F train

A removal against a dead time.

Il pleut. Nous parlons en français each other bopda.

On a monochrome street, you check your watch, frown, and choose instead to depart for dinner.

WORKS CITED

Theresa Hak Kyung Cha, *Dictee* (Berkeley: University of California Press, 2001).

Cathy Park Hong, *Minor Feelings: An Asian American Reckoning* (New York: Penguin Random House, 2020).

Eric Hackel, "Yvette Guilbert: La Diseuse," *The Kapralova Society Journal* 18, no. 2 (Fall 2017): 1–5.

Yvette Guilbert, *How to Sing a Song: The Art cf Dramatic and Lyric Interpretation* (New York: Macmillan, 1919).

Constance M. Lewallen, introduction to *The Dream of the Audience: Theresa Hak Kyung Cha (1951–1982)*, ed. Constance M. Lewallen (Berkeley: University of California Press, 2001), 1–13.

This essay was previously published by the *Evergeen Review* on December 23, 2022, https://evergreenreview.com/read/diseuse-in-a-dead-time/.

MOTHER TONGUES 로 번역하기
TRANSLATING INTO 모국어
SUJIN LEE

Mother Tongue 모국어하기
Translate into 로 번역

I first encountered Theresa Hak Kyung Cha's *DICTEE*[1] in a class called Artists Using Text, taught by Frances Richard. As I struggled to understand this book of idiosyncratically arranged and collaged text and images, the physical experience of reading aloud the section "DISEUSE" provided me with an entry point.

However, reading *DICTEE* aloud is a challenging process. You must readjust your body and mind to the languages and structures of Cha's writing. There will be some parts you are unsure how to pronounce and others where you do not know where to begin. The book often makes you rethink the way you have been reading. Reading *DICTEE* is an experience in which you discover the gaps and overlaps between you, your language, and your body struggles to produce a sound.

DISEUSE

She mimicks the speaking. That might resemble speech. (Anything at all.) Bared noise, groan, bits torn from words. Since she hesitates to measure the accuracy, she resorts to mimicking gestures with the mouth. The entire lower lip would lift upwards then sink back to its original place. She would then gather both lips and protrude them in a pout taking in the breath that might utter some thing. (One thing. Just one.) But the breath falls away. With a slight tilting of her head backwards, she would gather the strength in her shoulders and remain in this position.

Excerpt from page 3 of Theresa Hak Kyung Cha's *Dictee* (Berkeley: University of California Press, 2001).

1 Considering Theresa Hak Kyung Cha's tendency to place multiple meanings in a word by omitting, changing, cutting, and combining, I believe it is appropriate to follow her and keep the work titles *Dictee* and *Exilée* in all capitals without the diacritical mark.

VOICE(S)

When I first saw Cha's video piece *Vidéoème,* I was certain I had heard the voice before but could not figure out when and where. Later I realized that I had seen *EXILEE* in an exhibition titled *KOREAMERICAKOREA* in Seoul.[2]

I remember hearing Cha's voice as I walked into the room where the video was playing. Although I knew nothing about the artist, I had the impression that she was also "from a far"[3] and deeply interested in language. Maybe because I heard the voice before seeing or reading Cha's work, I have always felt that her work had a voice-like quality—nearly inseparable from language but resistant to being captured by it, carrying a potent reminder of the body even when estranged from it.

2 The exhibition was held from May 27–August 6, 2000, at Art Sonje Center in Seoul, Korea. The participating artists were Byron Kim, Carole Kim, Theresa Hak Kyung Cha, Do Ho Suh, Iara Lee, Ik-Joong Kang, Kim Soo, Kwon Sowon, Michael Joo, Shin Kyungmi, and Yunhee Min. It was curated by David A. Ross and Sunjung Kim.

3 Cha, *Dictee,* 1.

TERTIUM QUID

There are many "twos"[4] in Cha's work, yet two is never just two when you spend time with it. English and French are sometimes presented side by side in *DICTEE*. One is not a "faithful" translation of the other; some parts are omitted, added, or transformed as they pass from one language to another.

Ecrivez en francais:
1. If you like this better, tell me so at once.
2. The general remained only a little while in this place.
3. If you did not speak so quickly, they would understand you better.
4. The leaves have not fallen yet nor will they fall for some days.
5. It will fit you pretty well.
6. The people of this country are less happy than the people of yours.
7. Come back on the fifteenth of next month, no sooner and no later.
8. I met him downstairs by chance.
9. Be industrious: the more one works, the better one succeeds.
10. The harder the task, the more honorable the labor.
11. The more a man praises himself, the less inclined are others to praise him.
12. Go away more quietly next time.

Traduire en francais:
1. I want you to speak.
2. I wanted him to speak.
3. I shall want you to speak.
4. Are you afraid he will speak?
5. Were you afraid they would speak?
6. It will be better for him to speak to us.
7. Was it necessary for you to write?
8. Wait till I write.

4 Trinh T. Minh-ha also writes about the "twos" in Cha's work: "There are, as life dictates, many twos; each equipped with their sets of intervals, recesses and pauses. Many and one between(s). The third term, as I would call it, by which the creative potential of a new relationship is kept alive between strategic nationality and transnational political alliance." See Trinh T. Minh-ha, "White Spring," in *The Dream of the Audience: Theresa Hak Kyung Cha (1951–1982)* (Berkeley: University of California Press, 2001), 40.

These pages in *DICTEE* present two groups of English sentences with instructions to "Write in French" and "Translate into French." In order to do these exercises, you must ask yourself: how is translating different from writing? The second set, which is to be "translated" into French, is explicitly about speaking and writing. "I want you to speak," "Were you afraid they would speak?" "Wait till I write." These phrases imply a relationship in which one is authoritative and the other should be compliant. What exactly should be translated here, and who decides the legitimacy of the answers? The awareness, questions, and resulting uneasiness stirred up by Cha's juxtaposition of two concepts and entities—often seemingly in opposition to each other, or hierarchically ordered, such as text and translation, teacher, and student (or language learner)—which I will call the third space.

9. Why didn't you wait so that I could write you?

Complétez les phrases suivantes:
1. Le lac est (geler) ce matin.
2. Je (se lever) quand ma mère m'appeler.
3. Elle (essuyer) la table avec une éponge.
4. Il (mener) son enfant à l'ecole.
5. Au marché on (acheter) des oeufs, de la viande et des legumes.
6. Il (jeter) les coquilles des noix qu'il (manger).
7. Ils (se promener) tous les soirs dans le rue.
8. Elle (préférer) le chapeau vert.
9. Je (espérer) que vous m' (appeler) de bonne heure.
10. Ils (envoyer) des cadeaux à leurs amis.

Pages 8 and 9 from *Dictee*.

From A Far
What nationality
or what kindred and relation
what blood relation
what blood ties of blood
what ancestry
what race generation
what house clan tribe stock strain
what lineage extraction
what breed sect gender denomination caste
what stray ejection misplaced
Tertium Quid neither one thing nor the other
Tombe des nues de naturalized
what transplant to dispel upon

Page 20 from *Dictee*.

Instead of referring to this third space as an "in-between," I choose to use the word "around." In this "around-space," location is not fixed but fluid. Therefore, the relationship with and distance to the two spaces change. This space embraces perspectives in motion—which involves time and evolves in time; consequently, it is not settled, stable, or static. It enables awareness of how to navigate the "reality whose textures and complexities are still rather hidden and unarticulated in mainstream society"[5] while one reconsiders what it means to read, speak, and write.

5 Jennifer S. Cheng, "Theresa Hak Kyung Cha: Mother Tongue as White Noise, Water, Wind: Refracting Linguistic Identity," *Jacket 2*, August 6, 2016, https://jacket2.org/commentary/theresa-hak-kyung-cha-mother-tongue-white-noise-water-wind.

MOUTH TO MOUTH

m o u t h t o m o u t h

ㅏ ㅑ ㅜ ㅓ ㅕ ㅡ ㅗ ㅛ

Theresa Hak Kyung Cha, *Mouth to Mouth*, 1975. Letraset on board, 20 × 30 inches. According to the exhibition catalog *The Dream of the Audience*, "[t]his work shows the Korean vowels that are the basis of Cha's video of the same title."

Cha's single-channel video *Mouth to Mouth* (1975) begins with eight Korean vowel phonemes. Then, TV static fills the screen, and a mouth appears and overlaps with the static, seemingly enunciating each vowel that has just slid by.

Theresa Hak Kyung Cha, *Mouth to Mouth*, 1975 (stills).

MOTHER TONGUES

However, the shapes formed by the mouth do not exactly match the vowels, which still troubles me as much as the Korean references in *DICTEE* that refuse to be clearly explained or understood. Instead of the sound that corresponds to the shape the mouth forms, one hears birds chirping, water babbling, and static noise. Although static typically means "no signal"—i.e., no image or sound—what it represents is both the absence of legible image and sound, and the presence of image and sound that signify "non-image" and "non-language," respectively. In *Mouth to Mouth*, the dualistic nature of static heightens awareness of how one reads what they see and hear.

TV static—the noise—is the third space. The fact that the word "static" in its adjectival form means "unchanged, fixed, or stable" creates some intriguing tension within the image of the static. The notion of stability is contradictory to the "noisy" image, which is caused by random signals in motion. Static also represents both stillness and movement. Though the "ants" are constantly moving, there is no sense of time amid the static—it is as if time has stopped. The static in *Mouth to Mouth*, however, holds temporality as it functions as a transition to the image of the mouth.

Is the mouth silent? *Mouth to Mouth* is often interpreted as the loss of one's mother tongue. However, I read the piece as an acquisition in progress—a transition to self-expression and empowerment by articulation not necessarily translatable through language. Jennifer S. Cheng writes, "Even a literal loss of a mother tongue (truly, a mother's tongue) is not a completely empty silence, but rather it is full of splinters and din. It also cradles an emotional immensity—something is left in its imprint, like a hefty shadow."[6] These "splinters and din" resonate in Cha's work as different languages intersect, complicating and enriching the self as a speaking subject.

6 Cheng, "Theresa Hak Kyung Cha."

EXILEE

EXILEE is an installation comprised of a video playing on a monitor, embedded within a projection screen on which is shown a Super 8 film. One image shows an envelope covered with snow-like grains, visually echoing the static in *Mouth to Mouth*. Soon, the grain disappears, leaving an impression of its body.

Theresa Hak Kyung Cha, *Exilee*, 1980, Black-and-white photographs documenting installation incorporating Super 8 mm film and video, 50 min, sound.

The video in *EXILEE* consists of still images, and the film contains both still and moving images. Cha's voice recites a text twice: a text in two parts. At first, the second part seems to be a repetition of the first; however, it becomes apparent they slightly diverge. They are each other's variations. Two is not one, but two is not two either.

Twice two times two

has been said one on top below of another one.

before the other one arriving following

the next other

twice two times one on top below another one before

the other arriving following the next one

Excerpt from page 41 of Theresa Hak Kyung Cha's "Exilee," in *Exilée and Temps Morts: Selected Works*, ed. Constance M. Lewallen (Berkeley: University of California Press, 2009).

MOTHER TONGUES

In *EXILEE,* when the two come together—video light and film light, still images and moving images, initial utterance and "repeated" recitation—another space is produced. This is a space without an original, a space created through the "translation" and "adaptation" of each component and its multiplications, complementing each other while remaining decidedly fragmented.

Born and raised in South Korea, I moved to the US in the late nineties. When I returned to Seoul in 2014, I found myself in this unexpected, unnamed space. I was a Korean who happened to spend too much time in the US—where my status was neither American, Asian American, nor Korean American, but that of a "temporary visitor." Feeling that the word "in-between" was inadequate to define me, I began searching for my place around the two languages I speak—Korean and English.

When I was in the US, people often asked me why I used English in my work. "Why not speak in Korean, your native language?" This question returned to haunt me when I participated in artist residencies in non-anglophone countries.

As in many other places, English is a powerful language in South Korea. In this country where I hold citizenship, the term 원어민, meaning "native speaker," often presumes a white, native English-language speaker from North America or the UK, particularly in an educational context, despite the non-specificity of the term itself. Linguistic hierarchy and language ownership prevail in and out of "English-speaking" countries. Soon after I returned to South Korea, I struggled with these questions: What does it mean to speak and write in English in my work? What kind of English am I speaking? Such questions drew me out of the "in-between" space I thought I had belonged to and showed me the third space, where I could acknowledge the non-singular, variable nature of my own relationship to the languages I speak and write. I believe that the English language—especially the idea of what English is and how it should sound—needs to be constantly questioned to remind us of the space occupied by the variations, dialects, and accents of the English language, which have already been present throughout history. One should question the idea of English belonging to particular nation-states or racial groups and normalize the diversity and expansiveness of the language. Is the notion of the original still valid in speaking and writing in language? There is no such thing as an original (English) language when languages are constantly rewritten, reinvented, and "retranslated" to reflect the reality of the speakers. If English is considered the current global lingua franca, it should be written in a plural form: "English languages."

DICTEE's "Elitere Lyric Poetry" closes with an image resembling a handprint. You must physically pull your body away from the page to see it. It is an act of shifting your perspective and placing yourself in a different position. The handprint is both documentation and memory of the hand that is no longer there. You must read the space that is at once negative and positive, empty and full, absent and present, to recognize the image. The physical repositioning draws your attention beyond the page, to the materiality of the book, and eventually to your own body, which enters another space within—tertium quid—to recognize the act of reading.

Left: Page 134 from *Dictee*.

MOTHER TONGUES[7]

Cha's work presents not a singular origin, but a space of awareness created by translated and adapted entities. A translation can never be complete or perfect. There cannot be one translation; the word "translation" already implies plurality. There is always the possibility of rewriting a translation. Translations do not have to be a copy or a replacement of the original, nor do they need to be considered inferior to the original; they can function as a vehicle for challenging conventions.

Most nouns in Korean can stand for singular or plural; therefore, both "mother tongue" and "mother tongues" will be translated to 모(국)어. There is still a myth that Korea is a homogeneous nation with one language and one blood. In response to that notion, I would like to close by placing these two words that are each other's translations side by side.

7 This text was written for a seminar titled "Mother Tongues" at Wendy's Subway. I was pleasantly surprised by the title's plurality, which reorients the idea that "mother tongue" is the most powerful, unfaltering term to represent the first or singular origin, which for some, comes with a lot of emotional and cultural baggage. Like English, the "mother tongue," can be adopted, translated, personalized, or even multiplied.

모(국)어 Mother Tongues

Homonym ~~*Error*~~
YOUNA KWAK

PART I
DICTÉE

"Dictation" = pedagogical exercise consisting of a brief text dictated aloud by a teacher to students to be transcribed word for word with the aim of producing a perfect written transcription of what was spoken.

For example: if this were a *dictée* I'd read this text aloud & you'd be expected to write down precisely what you heard (and it might look like this).

Open paragraph It was the first day period
She had come from a far period tonight at dinner
comma the families would ask comma open
quotation marks How was the first day interroga-
tion mark close quotation marks at least to say
the least of it possible comma the answer would be
open quotation marks there is but one thing period
There is someone period From a far period
close quotation marks

Above and right: Excerpts from page 1 of Theresa Hak Kyung Cha's *Dictee* (New York: Tanam Press, 1982). All citations in this text from this edition.

HOMONYM ERROR

Aller à la ligne C'était le premier jour point
Elle venait de loin point ce soir au dîner virgule
les familles demanderaient virgule ouvre les guil-
lemets Ça c'est bien passé le premier jour point
d'interrogation ferme les guillemets au moins
virgule dire le moins possible virgule la réponse
serait virgule ouvre les guillemets Il n'y a q'une
chose point ferme les guillemets ouvre les guille-
mets Il y a quelqu'une point loin point ferme
les guillemets

Open paragraph It was the first day period
She had come from a far period tonight at dinner
comma the families would ask comma open
quotation marks How was the first day interroga-
tion mark close quotation marks at least to say
the least of it possible comma the answer would be
open quotation marks there is but one thing period
There is someone period From a far period
close quotation marks

> It was the first day. She had come from afar. Tonight at dinner, the families would ask, "How was the first day?" At least to say the least of it possible, the answer would be "There is but one thing. There is someone. From afar."

Aller à la ligne C'était le premier jour point
Elle venait de loin point ce soir au dîner virgule
les familles demanderaient virgule ouvre les guil-
lemets Ça c'est bien passé le premier jour point
d'interrogation ferme les guillemets au moins
virgule dire le moins possible virgule la réponse
serait virgule ouvre les guillemets Il n'y a q'une
chose point ferme les guillemets ouvre les guille-
mets Il y a quelqu'une point loin point ferme
les guillemets

C'était le premier jour. Elle
venait de loin. Ce soir au dîner, les
familles demanderaient, "Ça c'est
bien passé le premier jour?" Au
moins, dire le moins possible, la
réponse serait, "Il n'y a qu'une
chose." "Il y a quelqu'une. Loin."

What does this pedagogical exercise teach (or test)? A limited skill set, based on transposition from aural to written form; sound mimicry, but not language production; aural phonetic comprehension, not knowledge of grammar and syntax; spelling, not diction; cf. TLFi: *Exercice utilisé dans les classes pour enseigner aux élèves l'orthographe ou en vérifier la connaissance.*[1] (→ experiment? Give the same *dictée* to a fluent, illiterate speaker and a beginning, second-language learner. Would the texts they produce look different & how?).

Dictation = dictatorial (it's in the word!) e.g., its demands are rigid, coercive, unilateral (not dialogic, not dialectical) & there are only two subject positions possible: dictator & dictated-to (is there a word for this person?) (the *dictatee*) (but in seminar Laura Hyun Yi Kang says, *why not just "dictee"?*)

The text (as presented) does not conform to standard English or French.
Is this text:

 1) a script?
 2) a transcript?

i.e., is it 1) read by the dictator, or 2) transcribed by the *dictatee*? Unclear. Instability → resistance to or refusal of subjugation and colonial rule, esp. through language (violation, resistance, difficulty, loss). However: consider the ways that refusing the dictator still confirms one's position as the *dictatee*. Rather than resisting or refusing: frustrating, thwarting, eluding the paradigm → a "third meaning,"[2] Barthes's *neutre* (to outplay = *déjouer*).[3]

Ontological question: *what is this text?* If we allow only two possibilities/subject positions → is this:

 1) the text of the teacher?
 2) the text of the student?

1 *Trésor de la langue française informatisée*, s.v. "dictée."

2 Laura Hyun Yi Kang, "Compositional Struggles: Re-membering Korean/American Women," *in Compositional Subjects: Enfiguring Asian/American Women* (Durham: Duke University Press, 2002), 222.

3 Roland Barthes, *Le Neutre: notes de cours au Collège de France, 1977–1978*, ed. Thomas Clerc (Paris: Éditions du Seuil, 2002).

 HOMONYM ERROR

If the latter: *dictée* not as dictation but as *exercise* in dictation (performative), exposing how the dictator lurking in the *dictée's* shadows is but a clown (a clown-dictator is not without menace, but he has no guile). cf., nineteenth-century Parisian Minister of Public Education: "Is it not flagrantly obvious that most children have better things to do with their time?…[than to exercise] all the acuity of their minds on barely intelligible, at worst petty, grammatical nuances?"[4] cf., Verlaine, *dictée* as stupid punishment: "On m'avait placé dans l'étude des moyens…et c'était la coutume pour les élèves de cette catégorie qui étaient punis, de subir, en forme de pensum, une espèce de dictée latine ou française épelée mot par mot…."[5]

If the former (if this is the teacher's text): how slyly the student eludes correction! Producing a text that in has no *sonic* irregularities (*q'une* = qu'une; "point" or "period" spelled out in lieu of punctuation; lack of conventional capitalization). Secondly, since we don't have a confirmed origin text, it cannot be verified that this transcription is not indeed *perfect*. A *dictée* reproduces *what was heard*. (Is this what was heard? Who heard this?)

Also: this *dictée* is thwarted from the start, by the book's *title*. Absence of the diacritical mark (*DICTEE* vs *dictée*) as aberration (homonym, concerned with sound, eludes dictation → the diacritical mark's very purpose is to distinguish one sound from another & here it is *missing*).[6]

4 Léon Bourgeois, "Circulaire ayant pour objet d'interdire l'abus des exigences grammaticales dans la dictée (Paris, le 27 avril 1891)," in *L'enseignement du français à l'école primaire, textes officiels*, vol. 2, ed. André Chervel (Paris: Institut nationale de recherche pédagogique, 1995), 152–55. Translation mine.

5 Paul Verlaine, *Œuvres complètes*, vol. 5 (Paris: Librairie Léon Vanier, 1895), 46. As cited in *TLFi*, s.v. "dictée."

6 Theresa Hak Kyung Cha, *Dictee* (New York: Tanam Press, 1982). All citations in this text from *Dictee* are from this edition.

Above and right: Cover and title page, *Dictee*.

HOMONYM ~~ERROR~~

DICTEE

Theresa Hak Kyung Cha

훠

TANAM PRESS NEW YORK 1982

First Friday. One hour before mass. Mass every First Friday. Dictée first. Every Friday. Before mass. Dictée before. Back in the study hall. It is time. Snaps once. One step right from the desk. Single file. Snaps twice. Follow single line. Move all the way to the right hand side of the wall. Single file. The sound instrument is made from two pieces of flat box-shaped wood, with a hinge at the center. It rests inside the palm and is snapped with a defined closing of the thumb. Framed inside is an image of the Holy Virgin Mary robed in blue with white drape or white robe with a blue drape over her head, her eyes towards Heaven, two hands to Heaven, shrouded in clouds, the invisible feet. Framed inside next to her is the sacred heart of Jesus, a pierced heart enflamed single threaded thorn across above emanating silver light. Image of Jesus Christ pointing his left index finger to chest wounded mark on right hand reaching reaching perhaps ever so gently.

Excerpt from page 18 from *Dictee*.

diacritic, *adj.* and *n.*

A. *adj.*

Serving to distinguish, distinctive; *spec.* in *Grammar* applied to signs or marks used to distinguish different sounds or values of the same letter or character; e.g. è, é, ê, ë, ė, ē, ĕ, ę, etc.

Oxford English Dictionary Online, s.v., "diacritic."

What was heard to produce that wrong sound-word? Cha's use of diacritical marks is inconsistent throughout her work (but here it is supplied by critics, who therefore play the part of the "corrector" or "teacher").

cf. *EXILEE/EXILÉE.*

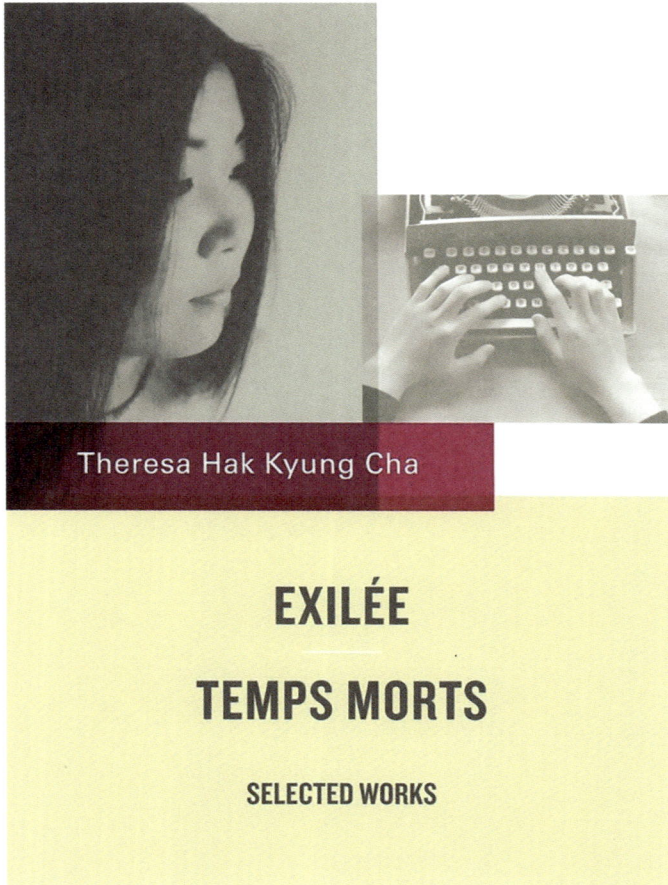

Above and right: Covers of Theresa Hak Kyung Cha, *Exilée and Temps Morts*, ed. Constance M. Lewallen (Berkeley: University of California Press, 2009) and *Exilée and Temps Morts: Selected Works*, ed. Constance M. Lewallen (Oakland: University of California Press, 2022).

EXILÉE TEMPS MORTS

SELECTED WORKS

THERESA HAK KYUNG CHA

EDITED AND WITH AN INTRODUCTION BY **CONSTANCE M. LEWALLEN** WITH A CONTRIBUTION BY **ED PARK**

"Le cygne," bilingual poem on p. 66: *J'écoutais les signes/J'écoutais les cygnes:* lines that are phonetically indistinguishable but different in meaning
→ they *elude* (thwart) dictation.

J'écoutais les cygnes.
Les cygnes dans la pluie. J'écoutais.
J'ai entendu des paroles vrai
ou pas vrai
impossible à dire.

I heard the swans
in the rain I heard
I listened to the spoken true
or not true
not possible to say.

Excerpts from pages 66–67 of *Dictee.*

J'écoutais les signes.
Les signes muets. Jamais pareils.
Absents.

I heard the signs. Remnants. Missing.
The mute signs. Never the same.
Absent.

Excerpts from pages 68–69 of *Dictee.*

J'écoutais les cygnes.
Les cygnes dans la pluie. J'écoutais.
J'ai entendu des paroles vrai
ou pas vrai
impossible à dire.

I heard the swans
in the rain I heard
I listened to the spoken true
or not true
not possible to say.

J'écoutais les signes.
Les signes muets. Jamais pareils.
Absents.

I heard the signs. Remnants. Missing.
The mute signs. Never the same.
Absent.

Excerpts from pages 66–67 and 68–69 of *Dictee.*

HOMONYM ~~ERROR~~

Another line that eludes dictation: *J'ai entendu des paroles vraies ou pas vraies/J'ai entendu des paroles, vrai ou pas vrai ?*

J'ai entendu des paroles vraies
ou pas vraies
impossible à dire.

I heard true or not true words—
impossible to say.

J'ai entendu des paroles vrai
ou pas vrai
impossible à dire.

I heard words—
is this true or not true? —
it's impossible to say.

Excerpts from page 66 of *Dictee.*

homonym, *n.*

1.

a. The same name or word used to denote different things.

b. *Philology.* Applied to words having the same sound, but differing in meaning: opposed to *heteronym* and *synonym.*

Oxford English Dictionary Online, s.v., "homonym."

Now rescue this thought from pedanticism.

Homonym. Two words having the same sound but different in meaning = homonym. Figure to thwart, frustrate, or elude. Synonym = taskmaster of language; Homonym = prankster. Translation's aim is to create "equivalence in meaning" translinguistically (the definition of synonym).[7] *Against the synonym* (in the "cygne poem": confusion of *entendre*/heard and *écouter*/listen: mistranslation is an example of disrespecting synonym).

(cf., other evidence of homonymic play in Cha's work:

Exilée,

$$\text{E X I L}$$

$$\text{E X I L E}$$

$$\text{I L E}$$

$$\text{É}$$

$$\text{É E}$$

Page 33 from Theresa Hak Kyung Cha, "Exilee," in
Exilée and Temps Morts.

7 *Oxford English Dictionary Online*, s.v. "synonym."

Commentaire,

COMMENT TAIRE

COMMENTAIRE

Pages 209 and 216 from Theresa Hak Kyung Cha,
"Commentaire," in *Exilée and Temps Morts*.

HOMONYM ~~ERROR~~

Passages Paysages, etc.)[8]

Synonym = equivalence of meaning, difference of sound. Homonym = equivalence of sound, difference of meaning. Homonym as a competing form of equivalence to synonym.

DICTEE eludes two synonymic readings:

1) *DICTEE*

> → *not* synonymous with Cha's body of work
> → This *posthumously published book* is singular in the corpus of an artist, filmmaker and writer, whose primary work was not printed books but rather videos, films, photographs, performance, film scripts, handmade books and sculptural objects.

2) *DICTEE*

> → *not* synonymous with Cha (the author, i.e., autobiographical)
> → "Thwarts the reader's desire to abstract...identity"[9] and "frustrates the desire to locate a single person within its covers."[10]

A posthumous work = collapses the distance between artist and work, making the two synonymous, equivalent in meaning.
Brandon Shimoda from the past seminar:

> It was a long time before I realized that a book could be written by someone who was not dead. It is not that I thought books were written by the dead—although some part of me thought that. But I thought that writing was what took place while the writer was alive, while a book was what took place—and *took the writer's place*—after they died.[11]

8 Theresa Hak Kyung Cha, *Exilée and Temps Morts: Selected Works,* ed. Constance M. Lewallen (Berkeley: University of California Press, 2009).

9 Lisa Lowe, "Unfaithful to the Original: The Subject of *Dictée,*" in *Writing Self Writing Nation: Essays on Theresa Hak Kyung Cha's Dictée,* ed. Norma Alarcón and Elaine H. Kim (Berkeley: Third World Press), 36.

10 Kang, "Compositional Struggles," 224.

11 Brandon Shimoda, "You write you/I write you" (Online seminar, Wendy's Subway, April 16, 2022).

Reading a living author, we are confronted with a dynamic, evolving, ceaselessly provisional biographical life in flux, moving in and out of the shadows of the work, and vice versa, so that perfect consonance between life and work is always elusive. A living author is unpredictable, apt to change her mind from one minute to the next. A dead author is fixed in amber, consonant with the work, whose afterlife doggedly outlasts the unstable continuum of her existence on Earth.

The exercise of the *dictée* (as metonymic for *text*) = a site of wider possibilities that can't be described in paradigmatic terms (i.e., nonconforming to paradigm); i.e., colonizer, colonized; maternal, foreign; dictator, dictatee; correct, error. Use of French as primary means by which paradigm is shattered, the third term, the third language, the neutral—to thwart the paradigm (Barthes).

dicter	infinitive
dicté	past participle
dictée	feminine noun
dictez	2nd person plural, present tense
dictait	3rd person singular, imperfect
dictaient	3rd person plural, imperfect

Synonym is prescriptive, definitional, diagnostic; homonym makes contingent meaning: *it errs* (i.e., not an error but an erring).

err, *v.*

2.

a. To go astray; to stray *from* (one's path or line of direction). Chiefly *figurative* and now *archaic*.

b. To fail, miss; also, ***to err from*** (a mark or proposed end): to miss, fail to strike. *rare*.

3.

a. To go wrong in judgement or opinion: to make mistakes, blunder. Of a formula, statement, etc.: To be incorrect.

†**1.** *intransitive*. To ramble, roam, stray, wander. *Obsolete*.

error, *n.*

I. Senses relating to wandering physically.

1. The action of roaming or wandering; hence a devious or winding course, a roving, winding. Now only *poetic*.

The primary sense in Latin; in French and English it occurs only as a conscious imitation of Latin usage.

II. Senses relating to wandering mentally.

†**2.** Chagrin, fury, vexation; a wandering of the feelings; extravagance of passion. *Obsolete*.

[A common use in Old French; cf. IROUR *n.*, < Old French *irour* anger, which may have been confused with this word.]

c1320–a1500

2.

a. To go astray; to stray *from* (one's path or line of direction). Chiefly *figurative* and now *archaic*.

HOMONYM ~~ERROR~~

(When I first encountered *DICTEE* at the age of nineteen, the readerly fantasy I unconsciously inhabited was not that the author was dead so that the book could take her place—one kind of synonym—but rather that I was the book's sole reader. This readerly phantasm as source of so much pleasure in my life → finding books, wandering in the stacks → why I'm sad for my students, their deprivation of that experience, not simply because I'm cranky and inflexible about the obsolete analog, but because of all the ways that, through digitization, search engines, algorithms, they are dispossessed of contingency in such a powerful way, divested of haphazard desire, the accidents of attraction.)

Synonym: I am *like* Theresa Hak Kyung Cha → not equivalence, but identification. A paraphrase of what Barthes writes about his attachment to Proust, to assure that his identification with Proust will not be confused with hubris: crucial distinction between equivalence and identification (for while one might be tempted to organize identification under the aegis of the synonym, which posits equivalence in meaning, my identification with *DICTEE* occurred under the sign of contingency, a kind of non-determinate contact or connection more closely linked to homonym as a form of equivalence than synonym.)

Lisa Lowe says this is an "aesthetic of infidelity," because even repetition is unfaithful & proves only "the incommensurability of forms to their referents"[12] But doesn't infidelity gesture toward fidelity as a utopian possibility? What about: an aesthetic of contingency? Not error, but *errance*; not infidelity, but *incidence*.

(Note: the work is *generous* → everyone can get in, somewhere; no one can get in *everywhere*)

(Note: *elucidation* not possible? you must *find a different gesture*)

12 Lowe, "Unfaithful to the Original," 37.

모(국)어

JENNIFER GAYOUNG LEE

Thanks to the innumerable efforts of scholars, artists, translators, poets, readers, and writers a generation before me, I first encountered *Dictee* in my high school library in 2015, when I ran into a friend who was chatting about it with our librarian, the Korean American novelist Eugene Lim. As he scanned the copy my friend had returned to the circulation desk, I was intrigued by a glimpse of Theresa Hak Kyung Cha's mother on the cover. Later, I found two copies of *Dictee* in the American Poetry section, a set of shelves curved around the circular table my friends and I used to chat over during lunchtime. But when I finally began reading the book, I was confused. What was Cha trying to say? What was the history being described in *Dictee*? Was it one I was supposed to understand?

At the time, I made sense of my confusion by associating it with my broader lack of knowledge about Korea and Korean history. As a second-generation Korean American, I had grown up knowing next to nothing about modern Korean history, so even the more clearly historical sections in *Dictee* were incomprehensible to me. But seeing the English language rendered so powerless, utterly unable to convey a linear sense of time or narrative, I was captivated. In all my literature classes, teachers had taken for granted the power of the English language to connect and humanize. In the few instances my English classes read books by writers of marginalized identities, it was through anglophone writing that these authors convinced even the most skeptical readers of their own humanity. But in *Dictee,* the English language did not invite me into the writer's world. It did not humanize Cha. Instead, the warped, pained English she offered up allowed me to give voice to a thought I had never been able to articulate: What if I did not want to engage in the exhausting task of making my own person-hood as a Korean American woman legible to anglophone readers? Could I choose otherwise? Who could I become if I rejected anglophone/American belonging?

Galvanized by these questions, I applied to a study abroad program that would allow me to attend a Korean high school and learn Korean for a year. When I was accepted, I was ecstatic. The program was fully funded by the US Department of State, though the implications of this funding didn't become clear to me until I had begun the program—that it had been developed to advance US national security interests overseas. It had never occurred to me to think about why the US government invests in Korean-language acquisition as a matter of national security: my parents had rarely spoken to me about Korea; the Korean War had only received a paragraph-long mention in my high school history textbook; and, after all, my own ignorance of the matter was in large part what had made *Dictee* so incomprehensible to me.

Of course, *Dictee* thinks through these questions about language, militarization, nationality. In The Quick and the Dead workshop on "Mother Tongues: Between Translation," Sujin Lee discussed the idea of a 모국어, which translates literally to "mother nation language." Kyung-Nyun Kim Richards's Korean translation of *Dictee* also translates the phrase "mother tongue" as 모국어, imposing this idea of the "nation" onto the concept of the mother tongue. I want to draw attention here to the ways in which *Dictee* and Kim's translation challenge the continuities between ideas of national and linguistic belonging, especially as they are disrupted through militarization. One of the cruel ironies I encountered as I entered Korea carrying my American passport, to be trained in the Korean language using American taxpayer dollars, was that my ability to learn Korean—to become comfortable, even fluent in it, and to experience life in a Korean high school, where I learned Korean history alongside Korean classmates for the very first time—was made possible not because I was Korean, but because I was an American citizen. It was my incorporation into the US military apparatus that allowed me to experience Korean not as the distant language of my parents, but as a language in which I began to feel comfortable, as if Korean were not just my mother's language but also my own mother (nation) tongue. Visiting the demilitarized zone and the Yongsan Garrison, hearing middle schoolers at a community center I volunteered at debate the Terminal High Altitude Area Defense (THAAD) deployments, and watching candlelight protests spread throughout the country to demand the impeachment of President Park Geun-hye, I struggled with the implications of my own complicity in US militarism. Yet as I encountered the material legacies of US empire in Asia in ways I had thought little about during my childhood in America, I was startled to realize that I was no longer confused by, but rather felt deeply understood by *Dictee*. "I have the documents," Cha writes,

모(국)어

Documents, proof, evidence, photograph, signature. One day you raise the right hand and you are American. They give you an American Pass port. The United States of America.... You return and you are not one of them, they treat you with indifference. All the time you understand what they are saying.... They ask you identity. They comment upon your inability or ability to speak. Whether you are telling the truth or not about your nationality. They say you look other than you say.[1]

The instability of nationality as identity; the assumptions made and broken about the parallel between nation and language; the ways in which taking on an American passport can render oneself unrecognizable as a Korean person when entering Korea; and amidst it all, *Dictee*'s insistence on speech—however stuttering—reminded me that even as governments, militaries, and documents might seek to circumscribe the truth of my own identity, language, and nationality, I was not alone in my desire for (and frequent failures at) self-expression. What I had not anticipated, yet what would become clear to me as I grew proficient in the Korean language, was that my own identity as a second-generation Korean American person had become increasingly illegible to those around me. Common second-generation experiences of illiteracy and discomfort in the Korean language, of feeling more "American" than "Korean," no longer resonated with me, and in turn, I found that my experience of Korean Americanness no longer made sense to the communities I had once identified with. But as I became unintelligible to those around me, I found in *Dictee* a kind of kinship and comfort, as I realized that what I had previously struggled to understand, I was now able to read as the Korean history I was learning in Korea, the Korean history I was watching unfurl around me in the protests for the impeachment of yet another president. And in doing so, I found—and continue to find—in Cha's work less a refusal than an invitation: an invitation to venture beyond the anglophone, to encounter Korean history, and, like *Dictee,* to become illegible to anglophone readers. 영어로는 알 수 없는, 그 모()어.

1 Theresa Hak Kyung Cha, *Dictee* (Berkeley: University of California Press, 2001), 56–57.

JENNIFER GAYOUNG LEE 111

It's for Always What Has Always Been
WIRUNWAN VICTORIA PITAKTONG

Dad speaks many languages. As the first son of Chinese immigrants to Thailand, he was born into Teochew, acquired Thai and Mandarin out of necessity, and English out of ambition. I regarded this multilingual ability as a survival trait, never a literary one. I should have known better, though. After all, he was the one who taught me English when I was young. For a Thai girl like me, mastering English is a ticket to conquering the world, Dad believed and reminded me often. To say "the" like an American, you have to stick out your tongue a little, as if you're biting it. Don't do that for "Thailand," though, or it will sound like "Thighland," like how Trump (mis)pronounced it in his August 2020 speech. And no, that's not an American you want to be. And remember, unlike Thai, in English each word bleeds into another like water, a river that flows until it reaches the ocean, full stop. There, you breathe. I would sing the raised note after a question mark and copy down his syntax over and over again. I learned to mimic him, learned to learn languages.

One thing he didn't specify about English was that this ticket only granted entrance to the competition called life; it didn't guarantee success, whatever that means. Take my dad, for example. In his own words, he "failed." Even though he succeeded in entering America, he didn't stay long enough for him and Mom to naturalize, didn't get rich or retire early. He was proud, though, that at least I was American. I was Victoria (and still am), for I was the first Pitaktong who was American at birth: I was our family's *victory*.

He told me about these stories during our weekly calls to make his "funeral book," formally referred to as the "Cremation Volume," a publication Thai Buddhist families prepare to distribute at funerals. Upon losing his sight, Dad decided he wanted to start "early" on his volume, so he would call me every week to narrate his life while I listened and typed the stories up quietly.

But his narrative irked me. He marked his life periods through his jobs, dividing them into pre-America, America, and post-America phases. The introduction, the climax, and the fall. His stories now caught up to the present, and up until this point, I had only been a listener and annotator. It had seemed he was the sole character and narrator controlling the narrative of a story that, in fact, involved many others.

So, I started asking questions, searching for those supporting characters in his stories. I raised honest doubts about how he never mentioned Mom in any of his stories, or the fact that he lied about the reasons for his return to Thailand from Tennessee, leaving behind opportunities to "make it." Naturally, sometimes Dad would answer the questions head-on, while at others, he would evade them completely or omit pieces of information (that I happened to know because others would tell the tales, too).

During these weekly conversations, we reconfigured the space between us and considered how much we wanted to reveal and conceal. To believe him, to see what he was omitting, to reconcile myself with some of the decisions he had made that I disagreed with, and more than anything, to accept him beyond his role as a father, I had to "read" closer, read between the lines, read to feel, and read, again. In this dance of shifting distance, we oscillated between foreignness and familiarity, omission and acceptance, knowledge and oblivion. And in doing so, these exchanges no longer demanded an absolute comprehension of the intended original. Rather, they begged for translation that dwelled in the limbo between the porous walls of meanings and subjectivities. To examine the familiar, one maintains a foreign distance, and to comprehend the alien, one needs to listen beyond words. Our conversations were a practice of translation involving all of these movements, swallowing meanings whole, ruminating in the suspended space between languages, and embodying them in other words.

These calls to make the "funeral book" were as much about life lived as they were about looming death. Tales of the former wouldn't have been told if not prompted by the latter. These interactions were like our English lessons back then—conditioned by some sort of practicality. However, even if such was the case, he was always the one to initiate them. Practicality is his way of justifying his actions. It's his language. And until this book *has* to be published, while we're waiting, I can learn to understand his language, learn to translate.

Dictee: *Spanish translation excerpt*
VALENTINA JAGER

TRANSLATOR'S NOTE

This is a translation in progress. Or rather, this is an excerpt of the progress of what a translation of *Dictee* could read like. The first step in what I wish to be an interminable succession of translations. A translation meant to be continually updated. Continually reframed. Continually respoken. Always in transition. As there are things I struggle to translate—partly because of who I am now and partly because I cannot find their equivalents in the language as it exists today—this is an ever-unfinished work. Yet, that possible "we"—the language and I—might come one day into existence.

In the following annotated draft—specially the first page—one of the main questions in translating from English is whether that section exists as a translation of the French, as an original, or as a translation without an original. Although three approaches might result in minor disparities of the final translation to Spanish, the function of the text in English would imply a different methodological approach for its translation: either translate it as-is, as separate autonomous syntagms (see p. 124) or replicate it as a translation of the French. Here I opted for a mirroring of the writing strategies, an echoing, so to speak. This involved a voluntary submission to Cha's directives, repeating the exercise, as the following pages suggest: "Complétez les phrases suivantes,"[1] "Translate into French."[2] A sort of echo of the text in the target language without eliminating the source language. A third text, I mean. Not instead of, but in addition to. In an imaginary exercise, the three languages could coexist on the same page: all as translations, all as originals. Yet, this draft attests to a negotiation. In its autonomous syntagms, the third text in Spanish is a translation without an original. Yet following a methodology of echoing, the triad remains implicit and the text in Spanish exists as a back-and-forth between the English and French.

1 Theresa Hak Kyung Cha, *Dictee* (Berkeley: University of California Press, 2001), 9.

2 Ibid., 14.

VALENTINA JAGER 121

Aller à la ligne C'était le premier jour point

Elle venait de loin point ce soir au dîner virgule

les familles demanderaient virgule ouvre les guil-

lemets Ça c'est bien passé le premier jour point

d'interrogation ferme les guillemets au moins

virgule dire le moins possible virgule la réponse

serait virgule ouvre les guillemets Il n'y a q'une

chose point ferme les guillemets ouvre les guille-

mets Il n'y a quelqu'une point loin point ferme

les guillemets

*traducir del inglés, o,
hacer lo que el inglés
hace (traducir del france*

¿Existe un párrafo
previo a
éste?

En inglés,
"había
venido"

Punto y a parte Era el primer día punto

Ella venía de lejos punto esta noche a la cena coma

las familias preguntarían coma abre comillas

abre signo de interrogación Salió bien el primer día cierra

signo de interrogación cierra comillas al menos

coma *por* decir lo menos posible coma la respuesta

sería coma abre comillas Solo hay una

cosa punto cierra comillas abre comillas

Hay alguien punto lejos punto final cierra

comillas

¿Y si es
eso lo que
está hacien

?

Ella imita ~~el hablar~~. *la dicción se* Que~pareciera al habla. (O cualquier cosa). Ruido desnudo, gemido, pedazos rasgados de palabras. Como vacila a medir la precisión, ella recurre a imitar gestos con la boca. El labio inferior se elevaría para luego hundirse en su lugar original. Ella juntaría luego los labios en un puchero aspirando el aliento que podría pronunciar un algo. (Una cosa. Solo una). Pero el aliento mengua. Con una ligera inclinación de cabeza hacia atrás, ella reuniría la fuerza en sus hombros y permanecería en esta posición.

Murmura por dentro. Murmura. Dentro está el dolor del habla el
dolor de decir. Más grande aún. Mayor al dolor de no decir. No
decir. Dice nada en contra del dolor de hablar. Supura por dentro.
La herida, líquido, polvo. Debe romper. Debe vaciar.

Ella libera sus hombros detrás del cuello. Una vez más pasa saliva. (Una vez más. Con una más es suficiente). En preparación. Aumenta. A un tono tal. Un bajo eterno, en acople. Autónomo. Autogenerativo. Traga con los últimos esfuerzos las últimas voluntades contra el dolor que lo desea hablar.

Ella permite otros. En lugar de ella. Admite otros para hacer multitud. Hacer enjambre. Todas las cavidades huecas por hincharse. Los otros cada

3

uno ocupándola. Capas tumorales, expulsan todo exceso hasta que en todas las cavidades ella es carne.

Se deja atrapar en su enhebrado, anónima en su movimiento espeso en la carga de su pronunciación. Cuando la amplificación se detiene puede haber un eco. Ella podría intentarlo entonces. La parte del eco. En la pausa. Cuando la pausa ya ha pronto comenzado y ha descansado ahí todavía. Ella espera dentro de la pausa. Dentro de ella. Ahora. Este mismo momento. Ahora. Ella toma rápidamente el aire, a bocanadas, preparándose para las distancias por venir. La pausa acaba. La voz envuelve otra capa. Incluso ahora más espesa. De la espera. La espera del dolor de decir. De no. Decir.

Ella asume la puntuación ajena. Ella espera cumplir esto. La puntuación. Suya. Ella se convertiría, a sí misma, en demarcaciones. Absorberla. Derramarla. Sujetar la puntuación. Último aire. Darle. A ella. El relevo. Voz. Asignar. Entregarlo. Darlo. Dar.

Ella transmite a los otros. Recitación. Evocación. Ofrenda. Provocación. La súplica. Ante ella. Ante ellos.

Ahora el peso comienza a presionar detrás de la parte más alta de su cabeza hacia abajo. Se estira uniforme, todo el cráneo se expande firme de todos lados al frente de su cabeza. Ella jadea de la presión, del movimiento de contractura.

4

DICTEE: SPANISH TRANSLATION EXCERPT

Dentro de sus vacíos. No contiene más. Surgiendo del vacío debajo, duros grumos de aire. Humedad. Comienza a inundarla. Disolviéndola. Lenta, alentada hasta la deliberación. Lenta y espesa.

Los trazos anteriores de su cabeza bajan cerrando sus ojos, en el mismo movimiento, más lento abriendo su boca junto a su mandíbula y garganta que caen cayendo justo al final no deteniéndose allí sino evirtiendo su interior en el mismo movimiento, desplazando completamente el peso para elevarse.

Comienza imperceptiblemente, casi perceptible. (Solo una vez. Solo una vez y agarrará). Ella toma. Ella toma la pausa. Lento. Desde lo espeso. La espesura. Del movimiento pundando hacia arriba. Alentado. A la deliberación incluso cuando pasó hacia arriba a través de su boca de nuevo. La entrega. Ella la toma. Lento. El invocar. Todo el tiempo ahora. Todo el tiempo que hay. Siempre. Todos los tiempos. La pausa. Pronunciando. Suyo ahora. Suyo desnudo. El pronunciar.

— la pausa suya
— El pronunciar suya

* Estas primeras páginas fueron traducidos con la ayuda de Majo Delgadillo y su muy detallada lectura, y con la crítica y apoyo de José Peña Loyola y Griselda Santos Guevara.

Smallness and Translation
SERUBIRI MOSES

W. G. Sebald describes the writer Robert Walser in terms of smallness.[1] This was, in part, due to the "pencil method" Walser used in his notebooks—a way of inscribing so miniaturized it rendered his writing barely readable. Still, Walser's microscopic writing held not only the readable content, but also the intensity that Sebald renders as an act of "solitary walking," or the more harrowing experience of confinement, such as Walser's many years in an asylum. Readable content may not adequately capture this solitude or the intensity of loneliness. The problem of the small could also be a problem of translation, since as Franz Kafka—a contemporary of Walser—reminds us: all language is a poor translation.[2] Theresa Hak Kyung Cha similarly used strategies of the small in her books, where we encounter microscopic images and close-ups, reminding us of the latter's capacity to reveal the intensity present in the era of silent film and harking back to the artist's own investigation of cinematic apparatuses, moving image, and photography.

1 "He is...a clairvoyant of the small." W.G. Sebald, *A Place in the Country* (New York: Random House: 2013), 138–39.

2 "Kafka says that all language is but a poor translation." Kazim Ali, "Doubt and Seeking," in *A God in the House: Poets Talk About Faith*, ed. Ilya Kaminsky and Katherine Towler (North Adams, MA: Tupelo Press, 2012), 32–46.

Thinking the microscopic in Cha's *Dictee* brings the problem of translation into relief. The cover image for the first edition of *Dictee* on Tanam Press shows a series of rocks arranged in linear progression, a composition in perspective. In more recent editions, such as the 2009 from Berkeley University Press, the photograph is reproduced on the inside of the book surrounded by a black background. Cha's frequent use of found photographs reveals that it is unlikely that she took the photograph of the rocks herself—it is more plausibly a reproduced found photograph. The image's technical proficiency illustrates how natural forces acted on the rocks by wearing them down in ways that could still be visible to the eye. These details show how the empty landscape centers the rocks, which appeared like a geological study. Cha's use of found photographs evokes such historic precision that she recalls how the visual form presents a similar microscopic frame in her literary and poetic form.

In Cha's 1977 artist book, *Father/Mother*, photographs of her parents before their migration to America in 1963, colored xeroxes, and Korean calligraphic writing spread across ten pages. We could speak of the "small" in her visual language, where two photographs are so varied in reproduction that they literally conjure multiple figures and meanings. From two images, many more emerge. The same approach appears in her artist book of the same year, *Population Ring Clifton Street*, in which the same scene of leaves on the ground, taken as close-up, recurs with minor alterations throughout the book. The images appear in the pages of the book interspersed with French text. Here Cha brilliantly channels an act of translation that has to do with making small adjustments: altering the close-up image ever so slightly, while changing the meaning of the image with each new line of text. In these minor adjustments, the problem of translation emerges as an accumulative strategy of meaning making in both written and visual language.

Το άλλο σόι[i]

)Miracle Is the Punctuation's Mark on the Psyche(

CATERINA STAMOU

In a basket of variants, they added the whispers, the last elegiac
couplets watered by their kin

On the absence of alphabet, a mother grows the freedom
to be misconstrued. She writes misconstrual family
letters on the ground for her only child
she lulls her with word she walks her like undulation she
holds θηλυγλωσσία[ii] in her hands.
Her name is Ήριννα.[iii] She sows scripts on the soil. One day
her feet will write

Αθήνα δε σε αναγνωρίζω πια[iv]

The child speaks only Greek. She sprouts out of poetry seeds
out of silence & self-preservation. She calls herself Ανύτη[v]
she says that poetry is the echo of the halting of fullness, of
a full stop's mark on the psyche.
In response to the ruling kin, she will research the accentual
relation between oxytones & turnstones
between the drilling sound pollution of growth and horror's rate
her voice will obliterate autocracy momentarily

momentarily πυκιναῖς πτερύγεσσι ἐρέσσων[vi]

The other mother is called Mirtha *Prompted silence*
Opalesque thoughts cast her *for the mother's kin*
dream they cast *for the mother's skin*
her right to opacity as in *is my memory of the sky*
ανορθόγραφη[vii] as in *theirs is it soft*
εξωφωνία[viii] as in *like the silk in Anatolia*
όποτε[ix] as in no
for the daughter whom she never
gave birth to

 her writing is punctuated by purport

she deliberately disputes her impermanence &
she dissolves τραύμα[x] ~~θαύμα~~[xi]

CATERINA STAMOU 135

The other daughter calls herself
Sappho, short for
Fanny, Aisha & Patrizia.
Related to the other mother
by tongue she dilutes her blood
ties into the notational flavor

Prompted laughter
for the father's meek
for when the fathers
speak in softness
all fortresses of words
are gone

of orange juice & question marks.

Intergenerational commas brackets hyphens lead
their dance with the nymphs

the rupture's continuum is sweet under a voice
that dictates the birds' wings

punctuated by the flutter
her mind glides

τραύμα θαύμα

In a basket of variants, they gave birth to
a foreign extended family they added red
flowers they read the hibiscus as in a dryad's dance
as in a mouth that never felt ready
as in telling my country
"I don't recognize you anymore"

Prompted θέρος[xiv]
for the harvest of one's own
dismembered
(kin's torture) wordemotion
a name to carry over
one's past, speech & dream

λεξοφορία[xii]
(=γιατί δε γράφεις στη μητρική σου
γλώσσα;)

They utter the variants like songs like
whispers they pass the basket over
the elbows in the shape of apostrophes they
watch the crescent moon forming a parenthesis
between)her & the curve of my back
you can see there is a sentence unattained,
I can hear the vacuity turning into lullaby(.

i Translation: "The other kin"

ii Neologism: Θήλυ (female) + γλωσσία (*glossia*), meaning "female language"

iii Erinna, ancient Greek poetess

iv Translation: "Athens I don't recognize you anymore"

v Anyte, ancient Greek poetess

vi Translation: "A flapping of thick wings" (lyric from Anyte's poem)

vii Greek, pronounced *anorthografi*, meaning "she who misspells, who makes spelling mistakes"

viii Greek translation of the word "exophony"

viv Greek for "whenever"

x Greek for "trauma," pronounced *travma*

xi Greek for "miracle," pronounced *thavma*

xii Neologism for "the carrying of words," pronounced *lexoforia*

xiii Translation: "Why don't you write in your mother tongue?"

xiv Greek, pronounced *theros*, meaning "summer"; origin of the Greek word *therizo*, meaning "to harvest," and the female name *Theresa*

The lines "one day her feet will write" and "the elbows in the shape of apostrophes / they watch the crescent moon forming a parenthesis" were developed after the writing prompt given by Lucía Hinojosa Gaxiola and Carolina Ebeid during the workshop "DIVINATORY POETICS—O as ORACLE," which they led in the last week of the Summer Writing Program (SWP) at the Jack Kerouac School of Disembodied Poetics in Boulder, Colorado, in 2022. The reference to "the right to opacity" and "exophony" is inspired by the way Eleni Sikelianos and Mónica de la Torre revisited these concepts in their artist talks during the same week of the SWP.

The poem converses with the book *Των Σιωπηλών Σπαράγματα: Ποιήτριες του Αρχαίου Κόσμου* (Fragments of the silent: poetesses of the ancient world) by Thanos Tsaknakis, published by To Rodakio in 2021, as well as Theresa Hak Kyung Cha's *Dictee*, and poems from her self-published artist book *Audience Distant Relative* (1977).

Το άλλο σόι

She
EUNSONG KIM

It is difficult to speak of Theresa Hak Kyung Cha because of how often they speak of her and for her. Such as, the expression on my professor's face upon discovering I was Korean (she alone knew this fact). At eighteen I neither had the courage nor the will to tell her that I found the text to be incomplete, in need of a second, third book and incapable of completeness in her presence. At eighteen I neither had the language nor the clarity to ask whether she thought her shortened life permitted her speech over hers or whether she used Cha's shortened life against her to enforce silence.

Do I now have the courage and the will? The language and the clarity?

<div align="center">*</div>

It is curious what is considered autoethnography. Whose life is considered legible material, and illegibly obscured. It feels too plain and boring to say this is racialized. Ezra Pound wrote critically about class and whiteness as a white man intimately familiar with the strictures of class. But, to be clear, Pound was an accomplished poet and a fascist. Forever and ever. Always and until.

And those who could never be classified as a Pound or play in the arena of surveillance as literature, such as those who are neither reporting on their lives nor on the lives of those they love and hate, those that will use it to harm them in casual conversation, or those whose writing is interrogated just as the police interrogate those deemed criminal: Analyzed within the hunt. Analyzed toward the kill.

But to be clear, I do not ever think the standards of whiteness are good enough for us. I do not think it's good enough that, because Pound is called a poet, and his whiteness undertheorized, as whiteness remains undertheorized, such would become our standards. What works for them does not work for us because we say so. What works for them must and will be broken by us.

Forever and ever. Always until.

<center>*</center>

But I am unbeginning, I am not talking about Cha or the text. I, too, remain plagued by that which surrounds and consumes her persona. Such as: I think white people are obsessed with *her* because they can call her a conceptualist and she won't talk back. Such as: I think her nascent unclarity around race facilitates this collapse. Such as: whenever I hear people discuss her, I think they are telling me about their white and whitened selves, more so than the usual lot. This is not a nationalist discourse. This is about our interactions with the dead, their undying, their language, their silence.

<center>*</center>

The nine muses structure *Dictee*, each one blessing or shielding a section as it moves from family history to family mythology, national discourse, and more. It is not always clear what the relationship between name title and section might be: is the section *on* comedy?—whatever that means—and is the writing on her mother the only tragedy? The imprecision situates the blessing. The vastness asks for curiosity.

The vague presence of Greek and Roman mythology, Sappho fragments, and Christian and Catholic dictums, add to the lure of *Dictee's* everlasting mythology, its weaving through foundational mythology with Korean anticolonial narratives and letters to her mother. This has been and is usually the stated rationale for the lasting impact of the text. The presence of Greek and Roman mythology signals Cha's reach into foundational Western mythology, and in this, allows us to interact with her text as familial.

The residue of Greek and Roman mythology in US society, it turns out, is rooted in the history of chattel slavery and settler-colonialism. At this point, it should be

safe to say that all epistemological routes (what we consider epistemological) take shape there: do with that what you will.

Consider Page duBois's *Slaves and Other Objects*, which takes us through how the study of classics in the US came via confederate generals, who looked to Greek society to justify the existence of slavery. DuBois demonstrates how we—those of us in the US—through these generals, are made to forget how Greek society was predicated upon chattel slavery, and in this, the foundations of Greek democracy interpolates slavery (as does the US). But she goes further: she argues democracy was invented with and through chattel slavery. This materialist argument should and must impact all nationalist discourse, all calls for freedom, as democracy has not been, and remains, a limited understanding of freedom, and is definitively against the liberation of all. Yet, few writers, few thinkers, write about Greek mythology or democracy this way.

DuBois writes that instead too many,

> [A]lmost unconsciously finding a utopian past in antiquity…one in which menial tasks and agricultural labor were invisibly performed by the unfree, those owned by the free with whom many readers identify.[1]

And in this, is Cha pointing to this myth, or does she partake in it? Is she writing on top of it? Or inside of it? DuBois states,

> The misrecognition of slavery has contributed to a myth of origin for Western civilization; an inevitable and necessary occulting of the presence of slaves has occurred. Such an invisibility implicates both antiquity and modernity. Antiquity has been preserved as a domain of origin, of philosophical or democratic purity, in many of the discourses tracing a trajectory from an ancient source. and modernity, contaminated as it is both by actual slavery and by racisms, by the result of recent slavery can refuse to acknowledge this contamination, misrecognizing it in the ancient past as well as in the present.[2]

DuBois advances that the myth of civilization is its construction of democracy with slavery, the fantasy of its greatness through slavery. When is the enemy abstract?

1 Page duBois, *Slaves and Other Objects* (Chicago: University of Chicago Press, 2003), 7.
2 Ibid.

DuBois also makes another important point about materialism (essential because the word "immaterialism" floats in often throughout Cha's text). Writing on a letter Freud sent to Romain Rolland, duBois points to how our longing for the past, our vision for the past, often contradicts its materiality. As in, the stories, the bones, the dust, and the systems constructed to create these objects and fragments hold actualities that contradict our desires for them. In the case of the knowledge of Greek and Roman texts: chattel slavery. In the case of fantasies of democratic revolution: chattel slavery.

Such as: the fragment of Sappho was found on which texture, made by whom and how, and how do we know this?

This is to ask: What can be understood about the possibilities *and* limitations of Cha's politics through her interpolation of Greek and Roman mythology. The only question I ever want to know is: *What are your politics?* Do they transform? Why or why not? How or how not?

<div align="center">*</div>

A detour that is not a detour:

Gilles Deleuze and Félix Guattari spent their life theorizing against the Western canon (Hegel was their target in particular) successfully. They have what is still considered the soundest critique and departure from the Hegelian dialectic—the notion that the dialectic is in "dialogue" toward progressive history—which seeps into so much discourse unbeknownst to the reader, writer, speaker, and thinker. It's the model of tech, the model of higher education and the humanities. "Critique" and "critical" thought are important, authorities prescribe, because they mend the system. The dialectic welcomes resistance because it understands it needs it to survive: it's a reform-based model of the world, one that many take up without knowing they do. That's how the master narrative works—it works *in* you. Through you. It works when you say you don't care about theory and history or the university, when you say you don't read you just write, when you say you're singular or exceptional or normal, it works through you because you know and don't know.

Hegel did not formulate the dialectic for liberatory purposes; he constructed it in order to situate the domination of Western civilization over everything else. Marx amends it to say we can understand the socialist future through the struggle between the bourgeois and the proletariat. They will struggle and the proletariat

will come into consciousness through the struggle (because they suffer) and then arrive. Progress requires this—their struggle.

It's a suffocating formula and it's everywhere. Adversity makes you stronger, they say. *She* arrives here because of the trials and tribulations over there. The narrative of overcoming. The narrative of opposition to overcoming.

Back to D&G who said no. This is not only a dangerous understanding of history and the future, but it's also incorrect. First, it's too simplified—are you sure it's a dialectic and not a chorus, a flood, a warring? We are sure there is more. Second, this theorem naturalizes suffering, violence. It mends it, says we need the sacrifice of some for the survival of others, philosophically. So instead, they offered the rhizome, a geometric shape taken from nature that speaks to the architecture of roots and rooting and spontaneous growth.

So those of us frustrated by Hegel and their kin have other Europeans we can turn to. And not only did D&G offer critiques of "master narratives"—including psychoanalysis, Marxism, and so forth, they advocated on behalf of global revolution. Guattari, in particular, spent the rest of his life in Brazil, working with members of the psychoanalytic community there to practice what would later be known as group analysis, an anti-individual approach to the practice of the psyche to activate on behalf of a group consciousness. He supported the radical actions taken by members of this community against the colonial state.

This is to say, they were serious, the most serious.

In "Can the Subaltern Speak?"—one of the most widely read essays in postcolonial literature—Gayatri Spivak, translator of French thinkers like Derrida, takes D&G and, I might add, those like D&G, to consider the subaltern. There are colonized and racialized subjects with access to representation who represent themselves. They are not subaltern. Their lives are terrible, but they are not subaltern.

In order to situate this, she navigates the story of Bhuvaneswari Bhaduri, who wanted to take part in revolutionary, political action but decided to take her life instead of the life of her opponents. She did, however, want her actions to be read not as the result of a love affair or pregnancy, so she waited until her menstruation to take her life. After her death, her family tells everyone it was because she was pregnant.

Every part of the story is to convince you that some people do not have access to representation. The fact that Bhaduri waited until her period. The fact that her life and death were her speech. The fact that she knew she would not be believed.

Theorists like D&G played with terms like "minor." They said, in their desire for revolution, that they and the West must look to racialized and immigrant writers and become alienated from language. Instead of abhorring and criminalizing them, they often said: Let's be like them. Instead of disciplining them, they said: Let's come up with theories that could help liberate them.

Yet the bottom is deeper, deeper than many want to admit, and revolutionary discourse is built upon images of their silence, the violence of those at the very bottom, narratives of how they've suffered and died. I think part of what Spivak is saying is: Can you help them if you have never heard them before? Especially if the conditions of your existence deny them not only speech, but existence?

*

Lisa Lowe reads *Dictee* as not offering an individual accounting of history but exceeding it.[3] Lowe reminds us that in the text, the images and memories of colonization do not contradict the presence of "emancipation." Lowe reminds that in Cha's text, the war has not ended (because it hasn't), and the violence remains ongoing. The dates: x number of years of colonization, the forced migrations, the Korean war, the division, the present, collide. They are ongoing because *the wound forgets the scar.* Language reminds us again and again: the wound forgets the scar.

Lowe's reading of Cha is also most useful for understanding the ways in which the "personal" here is not distinctive, but historical. As Saidiya Hartman has described, the accounting of the personal for members of the Black Radical Tradition is not to create a class of distinctive individuals, but to witness one's life as part of historical, communal forces.[4]

I wonder if this approach is trying to say: I am not my sister, do not witness me as such. But to contend: Sister, you are here, how much longer can we be here? Others remain. Sister.

3 See Lisa Lowe, "Unfaithful to the Original: The Subject of Dictée," in *Immigrant Acts: On Asian American Politics* (Durhamn, NC: Duke University Press, 1996).

4 Patricia J. Saunders, "Fugitive Dreams of Diaspora: Conversations with Saidiya Hartman," *Anthurium: A Caribbean Studies Journal* 6, no. 1 (June 2008): 1–16.

In a popular book about the banal exceptionalism of Asian Americans, a writer exclaims that the internet and the world has yet to see real images of Cha, and instead, confuses Cha's sister, Bernadette Hak Eun, for Cha. She laments this as evidence of injustice, as proof of the injury Asian Americans face of how, even the best of us—prominent artists—cannot be properly identified with our individual faces.

This claim to individualism, no *desire* for proper identification, you think, is pathetic and a testament to the reactionary politics of too many Asian Americans. This equivocation of individualism as justice is, at best, counter-revolutionary. They say again and again, write essays and memoirs and chapter after chapter about how hard it is to be invisible. To not be properly identified. Is the injustice that Cha's murder is linked to the structural violence of the state and police against Asian persons, women in particular, which remains ongoing to no avail—or that white people cannot tell her apart from other Asians when she is an *important artist*?

On days I have energy I want to respond to this neoliberal hysteria by reading passages from Manu Karuka's *Empire's Tracks*, where he traces the collisions between Indigenous Nations and those considered "Chinese" railroad workers. The word Chinese is in quotation marks, dear reader, because did you know that the archive states Chinese because the railroad companies could not tell them apart/did not want to?

The labor boats that supplied the workforce for the building of the railroad—unlivable conditions in which workers worked nine-to-ten hours in the mines daily without breaks against a whip—dispossessed people throughout the Pacific Ocean and Asia including the Philippines Malaysia Guam Hawaii and more. But the archive says *Chinese* because the white people and the Asian persons who profited from their exploitation then and now say *Chinese*. In an interview about the book Karuka goes into detail as to how the Central Pacific archive holds the wage cards of individual white persons, how much they were paid, by first and last name, and how the "Chinese" were consolidated into groups of twenty-five persons, their wages allotted as a racial group.[5]

*

5 See Manu Karuka, *Empire's Tracks: Indigenous Nations, Chinese Workers, and the Transcontinental Railroad* (Oakland: University of California Press, 2019).

Thus when the *New York Times* creates a wormhole on how sad and lonely it is to be Asian American (also sidebar, loneliness is the ultimate form of ordinary unhappiness, is it not…), because all they want to be is a distinct individual when witnessed as a collapsed racial group—it may be important to trace how we have never been witnessed as distinctive, but as category.

Then and now, the stakes of being identified, of having a proper first and last name, is one of capital. It ensures one's access to capital—access to proper individuation. The underlying sentiment here is proximity to, and desire for, whiteness. Is this why Claire Jean Kim says being invisible is as good as it's going to get in the racial order?[6]

DuBois writes of that with regards to slavery in Greek society: "invisibility and ubiquity are mutually conceptive, both for ancient thinkers and for modern scholars."[7]

What Kim doesn't say explicitly, but we can infer from her assertion and duBois's tension, is how the puncturing of invisibility is the abolition of the racial order. It is not individuation within it, more visibility within, but its fundamental rupturing of it: I am on repeat.

This is the onus and potential of the fictional category called race, against which the self believes it stands. They understood, understand you as a colonial subject. Do you know you're a colonized subject? Can you be a distinctive colonized subject?

<center>*</center>

You live without pride. you have never held and could never hold Asian American pride. What is the pride in American, what is the pride in Asian. What is the pride of a nation, for whom does the nation exist. You are not naive enough for pride. And yet, it does swell you with pride, whenever anticolonial action is celebrated as the standard in K-drama. You witness the causality in which actors disparage, fight, and kill colonialists and their defenders. You think, hell yeah, there's no fucken other side. No: it-was-hard-not-to-be-colonialists-they-had-to-live, they have a story too, you know, plotlines. It is simply: The colonialists must be fought, rejected, their perspectives unworthy of intellectualizing and recounting. Their

6 See Weishun Lu, "Framing Asian Suffering in an Anti-Black World: A Conversation with Claire Jean Kim," *Edge Effects*, September 23, 2021, https://edgeeffects.net/claire-jean-kim/.

7 DuBois, *Slaves and Other Objects*, 6.

sympathizers erased ontologically and chased from the lands and the pages of all cultural narrative. Fuck yeah.

You also think about academics who have argued that in the threshold of settler-colonialism, Korea was not colonized for long. The colonization of Korea, the extracting of its land and resources and the attempted erasure of its language was about forty, fifty years. Comparatively, this is a failed settler-colonial project. Comparatively, there are longer and ongoing settler-colonial projects, i.e., the United States. And yet, the colonization of Korea demonstrates how fifty years is the duration of a life. It was long enough to make people believe there would be nothing else, it was long enough to change education and language and signs, and it was long enough to create forced migration. Fifty some years was, in Janet Pooles's words, long enough to convince some writers that there was no future other than colonization. Yu Gwan-sun, Theresa Hak Kyung Cha, *she* did not ascribe to this future.

Fifty years was long enough to transform the imagination of a populace against settler-colonialism. It is considered a baseline to be Korean and against Japanese settler-colonialism. How does this baseline grow to encompass the anticolonial movements ongoing all around the world. This is to ask: Can this baseline become more? You're wondering and desiring for this baseline to become more.

What are you trying to say? You're trying to ask whether the attention and detail to unfold the violence of Japanese colonization in Korea was extended to the lands in which she moved and lived, from Hawaii to Berkeley to New York and elsewhere. How can we ask this? You want to ask this.

*

Anytime I think of Clio, I think, we need a muse (goddess of memory) to write history. I think Clio, muse of history, goddess of memory, blesses this line by Cha who writes:

> The enemy becomes abstract. The relationship becomes abstract.

> …

This document is transmitted through, by the same means, the same channel without distinction the content is delivered in the same style: the word. The image.[8]

Because this was the beginnings of critique: Because is the enemy abstract? Not for the muse of history. For the goddess of memory, the enemy has never been abstract. How dramatic and correct would it be to say: The enemy is abstraction. The enemy has been and will always be, abstraction.

*

You think about this *Vice* episode about plastic surgery in Korea. In the episode a tall thin white woman runs around Korea with no expertise no Clio no knowledge no analysis giggling any time a Korean woman tells her that she wants to look more like her. The episode is not about Korea or plastic surgery or, I'm sorry to break, CIA creative writing rules capitalism colonialism. The episode is her frolicking about, casually speaking to women and men you want to hold and slap and friend and stab telling her earnestly why they want, what they think they want. She doesn't care. She, like so many other colonialists before her, is there because she's not famous enough to be glib with the Aryans in her motherland. She is there with no expertise because the other lands do not require expertise. She is there to be pure surface, to make fun, to point out only the contradictions but never hers and then to never think of it again. She concludes the episode with what she clearly thinks is a profound question: well, if everyone gets surgery, what will their children look like? You can hear the giggle. You can hear their applause.

The episode does not could not go into how the surgery the white girl fixated on, that white people fixate on—the double eyelid surgery—what white feminists and others often point to as an example of internal colonialization, was invented by a US military surgeon during the Korean War. The episode does not and could never go into how in interviews (available on the wide web), the surgeon stated he performed the surgery on prostituted women and sex workers because he wanted them to not have the "eyes of the enemy." Crushing in its precision, devastating because accurate. The episode does not could not go into how the imagination of this man permeates throughout Korean and Asian societies as but one element of the presence of US empire. The memory of him fades from public discourse, as memories critical of empire are often redacted from what is considered public and so some begin to hold

8 Theresa Hak Kyung Cha, *Dictee* (Berkeley: University of California Press, 2001), 32–33.

an appearance befitting for US military surgeons and their imagination. Crushing in its precision, devastating because accurate.

The episode could not and does not go into this because it requires too much of the speaker and her lives. It requires her to ask questions about the imagination of the US military surgeon, such as: How are her eyes the eyes of their side? It requires her to demand too much of the criminality of all that she does not know. He changed faces thinking of her whiteness as *not* enemy—what could she make of this?

I bring the surgeon up not to lecture scold spread real news for Clio to shake the young out of the surgery they say they want: The point is never her ignorance but their criminality. The point is a wonder toward desire and its fears. You cannot lecture someone out of desire and in this, how do new desires take shape?

But to be clear:

Eyelid surgery was invented by a US military surgeon who wanted our eyes to look less like the enemy.

And did you know that the nose job—the removal of the bone the straightening of the bridge—was invented by a Jewish doctor in Germany who envisioned assisting Jewish persons in their assimilation?

Eyes nose closed mouth combined are the features of the protagonist. Who will call: Not enemy. Not enemy if you are here, if your non-enemy eyes are here do not cry. This is an order. We do not need you to cry we need to plunge your eyes just kidding never kidding. Non-enemy I am speaking to you like I imagine you here but I do not. You are invoked because I want you. I am staking how the features of their protagonist lacerates into eyes, nose, mouth, our eyes, our noses, our mouths. With no adherence to the natural with no allegiance to any past I am making a point about our faces. I am making a point about how their imagination of us becomes us and how much I want something else.

And forever I love you not because they call you enemy but because you are mine.

<p style="text-align:center">*</p>

You think about an article you read the first year of graduate school in Lisa Yoneyama's class on militarized knowledge, which traces the history of the Jeju

massacre, in which under the specter of US empire, the Korean police tortured, assassinated, and murdered the wives and girlfriends of suspected and known communists, anticolonialists. They targeted the women as an omen to the island. It was as if they said: If you love and want liberation, you and your loved ones will die.

Kim Seong-nae chronicles how their deaths, however, have become the occasion for men to speak.[9] Their deaths have become the occasion that authorizes their speech. Year after year, male politicians invoke the massacre and detail the murders of the women to say: Vote for me. They sacrificed for us to be…a block of votes? We have seen this before here, in many shapes. Year after year, their deaths (and not lives, not desires, not politics), a platform for the desires of others.

<div align="center">*</div>

You are distracted. You want something. You're just like everyone else in need and want of something. What do you want? You don't want to let yourself down the way others let you down. It's so difficult being perfect. What do you want? You want to be right, you want to verify that what you're feeling is toward the world you want but will never live in. What do you want? You want to know they miss you. What do you want?

You think about the poet whose poem about the women who were murdered in Atlanta in 2021 goes viral on social media. She writes that the unnamed women remind her of her mom. She writes the women could be her mom and states three were murdered but this is categorically false and being wrong does not matter. Prominent writers thank her for the poem. They say, thank you for the poem tear emoji. No one, not even a troll asks her about this doctored dead count. No one asks her for precision. No one expects this from her and poetry.

You've seen this before. There is an atrocity and poets offer a stupid poem that says: It could've been me, it could've been my mom. You walk by the 24-hour news channels and the commentators say: It could've been your mom, it could've been you. From poet to political pundit to politicians they agree. They agree the only way to imagine the dead is to envision them as your live kin, or worst, you. Which means. The only way to remember the dead is to think of yourself. Which means.

9 Seong-nae Kim, "Sexual Politics and State Violence: on the Cheju April Third Massacre of 1948," trans. Jiwon Shin, in "'Race' Panic and the Memory of Migration," ed. Meaghan Morris and Brett de Bary, *Traces 2* (2004): 259–91.

Think of yourself. What else is there to think about. From poet to pundit to politician say: Think of yourself. Amen.

You think about the murders at Pulse in Orlando and the various literary magazines that advertised for poems written by queer, gay, persons. For one issue, maybe two, they published rough drafts of poems written by queer, gay, persons. Is it insensitive for you to question the politics of their mourning or is it insensitive of them to remain unquestioned? Is it insensitive for you to question the politics of memory, how the dead are unremembered or is it insensitive for their metaphors to remain intact? Insensitive is not the right word. Fucked up is better. Is it fucked up for you to probe the recklessness in which mourning becomes institutionalized or is their self-centered reckless self-promotion guised within institutionalized mourning fucked up? Both?

You think often about writing to the literary magazines that advertised for poems after the shooting today to ask how the lives and deaths of the victims restructured their magazines. Has the staff held memorials since, is there a concerted effort to work with gay, queer, trans persons in the community, to publish all forms of their complex writings? Do the poets who wrote about the dead think about them when they are no longer in the news? Do they imagine them only in their poems about themselves or do they dream about them, think about them, search for their absences when they are walking, on screens, in the archives? Tell us how their deaths weigh on you today. You are not a liberal pundit or a poet so you ask for a commitment to the dead. Is this such a surprise? You are asking are you melancholic or narcissistic. You are remembering how Walter Benjamin said not even the dead are safe if the enemy remains victorious and you are wondering why so many of them act like the enemy and call you kin.

You still don't know a thing about the women who died, the people who died at Pulse, the people who continue to die. You don't know about their lives, and it feels like a lifelong commitment to learn about them. What are you trying to say. You are saying poetry is like everything and everyone else. You always say poetry is stupid like everything and everyone else. What else are you trying to say. You are saying you wanted poetry to be something unlike everything else and you are continually disappointed when it is not. What do they say about expectations. It is always your problem your expectations. You are wondering if their commodification will never stop. It is not enough to commodify your life and the lives of others and here you are, wondering can you fight the commodification of the death

of others. How much can you fight. How much do you have left? You are on the losing side. How hard can you fight.

<center>*</center>

Her formlessness is a misreading, consider:

You want a different body is code for you want a different mother. Do you blame me? So it is confessed that you cannot accept your lot. So you have never been and will never be a Christian a Buddhist a nonviolence trainer and still their guilt lives inside of you. So you can hear how you are not strong enough for acceptance. You are weak and full of desires that scare you. Such as the fantasies for memories not yours. A mother not yours. A childhood not yours. So you fantasize about familiar gardens savings accounts one home address lifelong friends love. So you protect what is yours what will never leave you and you fantasize about another. Do you blame her. Confess. Confess. Confess.

So you want a different body and a different mother and a different language and different dreams. So you cannot accept this life. So you fight.
So you fantasize. And protect. And fantasize. And protect. And consider:

you lose your body is a familiar movie trope
in the films
a man becomes a woman or a panda or a cat
or wakes up as a different person each day and sometimes the journey is about
getting your body back sometimes it's living inside this new body
sometimes but most times the self is reunited
with appreciation for their body because
few people can recognize you as someone something else
it turns out
memories are held in bodies and
the soul is not easily recognized it turns out
memories are trusted through bodies and
you need your body to be remembered
considered
it turns out
the soul is not so important
or, the soul is inconsequential without the body

thus consider reincarnation.
not the conservative ideology, where your allotment is because you were terrible
before but
a shape of life that moves in the circular
and says
perhaps you will meet again
love again
who will you recognize when you meet again?
can you transform to love a bit longer
murder more strategically
fight on behalf and fight to win
consider an understanding that believes
your body is yours and temporary
your memories are yours and everlasting
consider

amen

Exorcising the Haunted Desire for Legibility
YOUBIN KANG

Death sparks spectacle. The contemporary militant and partisan labor movement in Korea began after the self-immolation of the garment worker, Jeon Tae-il, who died in November 1970 in the hustle and bustle of the garment district, crying out these words: "Follow the Labour Standards Law. We are not machines. Let us have Sundays off. Don't exploit the workers. They are not machines."[1] South Korea's economic development, induced by the sweated muscle of predominantly female garment workers, was a morbid affair. Yet, without Jeon Tae-il, his body aflame with the collective desire of workers toiling in the factories, there would be little recognition that garment workers were, indeed, beloved daughters.

The martyrs in Theresa Hak Kyung Cha's *Dictee*, including Yu Gwan-sun, An Jung-geun, Thérèse of Lisieux, and Joan of Arc, are holy and sacrificial figures conjured for a similar purpose.[2] In a world in which power is maintained through the state's control over life,[3] sensational martyrdom can also be an instrumental weapon. Like the self-immolations that sparked revolutions in China and the Middle East, or the suicides deployed as tools for labor protest in many parts of Asia, the invocation of martyrdom and death made sacred has instrumental value.

But when death is the tool for producing legibility—permission for the marginalized to be deserving of recognition—it is bound to complicate how the living consider their own bodies. This practice of sensationalized, pornographized

1 Cho Young-rae, *A Single Spark: The Biography of Chun Tae-il,* trans. Soon-ok Chun (Seoul: Dolbegae Publishers 2003), 315.

2 See Ken Chen, "The Stakes of *Dictee,*" *The Yale Review* 110, no. 3 (Fall 2022).

3 See Achille Mbembe, *Necropolitics* (Durham, NC: Duke University Press, 2019), and Michel Foucault, *The History of Sexuality,* vol. 1, *The Will to Knowledge,* trans. Robert Hurley (New York: Vintage Books, 1990).

invocation is anything if not revulsive, as is the idea that one must die to be granted dignity, to escape, to have purpose. The perverse allure of death is also hinted at in *Dictee*. Cha mischievously presents the two Christian martyrs, Thérèse of Lisieux and Joan of Arc, by way of their fictional counterparts in movies rather than through their historical representations or photographic portraits, to point to the theatrics of martyrdom, and she also summons the sensual and intimate desire for the yoke of Jesus expressed by female saints.[4] Unlike the performative prose of writers seeking to solicit superficial tears, however, Cha's conjuring of this specific kind of haunted sensuality has a distinct purpose: it directs us to move through that peculiar desire, but also to exorcise it.

The anguished and fragmented cry of the marginalized to gain legibility signals to the concurrent desire for attaining visibility and invisibility from those who hold the gaze: the colonizer, the elite, the capitalist, the male, and the white. The marginalized might seek visibility in instrumental ways, through self-fetishization and self-to-kenizing narratives, for instance, simply to borrow love and community, even if this love is superficial or transactional. At the same time, the marginalized are everywhere rendered invisible.[5] Outsourced labor through global supply chains renders workers imperceptible to legal systems and consumers across borders, while the racialization of marginalized workers diminishes their value, justifying their dehumanized treatment. The marginalized also invisibilize themselves, whether through the uneasy attempt to assimilate and blend in, or through rebellious, fugitive acts to escape the opportunistic reach of exploitation. Scholars have variously conceptualized the source of these desires as double consciousness,[6] false consciousness,[7] and misrecognition.[8] These psychosocial descriptions can be inherently violent and prevent emancipation. They point to the ways that the dominant misrepresent, thwart, and silence the marginalized to be able to live their truth and potentially also their ability for broader collective action.

4 Chen, "The Stakes of *Dictee*."

5 See Gayatri Chakravorty Spivak, "Can the Subaltern Speak?" in *Marxism and the Interpretation of Culture,* ed. Cary Nelson and Lawrence Grossberg (Basingstoke, UK: Macmillan, 1988), 271–313

6 W.E.B. DuBois, "Of Our Spiritual Strivings," *The Souls of Black Folk* (Boston: Bedford Books, 1997), 2; Frantz Fanon, *Black Skin, White Masks,* trans. Richard Philcox (New York: Grove Press, 2008).

7 Louis Althusser, *Lenin and Philosophy and Other Essays,* trans. Ben Brewster (New York: Monthly Review Press, 1970), 164.

8 Pierre Bourdieu, *Outline of a Theory of Practice*, trans. Richard Nice (Cambridge, UK: Cambridge University Press, 1977).

This violence—often a *desire* for violence—runs through Cha's work and takes expressive form in the illegibility she produces. It is a haunted desire that is difficult to articulate simply in political, economic, or sociological terms—as DuBois, Fanon, Althusser, or Bourdieu have done—perhaps because it is embodied and complex in the same way that a proletarian revolution would never yield a single, simple resolution. It lies somewhere between the desire of the Christian women saints whose taboo, sensual longing for Christ is intended to transcend patriarchal oppression; Cha's employment of language to surpass the Japanese and American colonizers who undermined her ability to speak; and the shame of being alive in the midst of so much death and suffering.[9] *Dictee* speaks to the audience at this intersection, one who understands that emancipation transcends the false duality of the personal and political, and the liminality between life and death.

Cha's ghosts are summoned for the purpose of exorcism[10] and transcending trauma.[11] *Dictee* should be considered among the lineage of literature by marginalized women who reckon with ghosts through a spiritual and ritualistic guide for how to live on. One such prominent predecessor would be Toni Morrison's *Beloved*. The specter, Beloved, is a needy phantom who forces the world to reckon with the ghosts of slavery that continue to haunt present America. Beloved, however, is not conjured just to remind in "rememory"; she is beckoned to guide toward the possibility of life by the very fact of her ritualistic exorcism by the community.[12] The works of Bhanu Kapil and Kim Hyesoon also touch upon these themes through rhythmic and meditative rituals. Kapil's *Schizophrene* grapples with the fragmentary trauma of migration and borders, finding its antidote in a rhythmic, consistent, light touch akin to ritualistic prayer in the Hindu tradition.[13] Kim's poem "Face of Rhythm" also suggests that the rhythmic processes, sounds, and properties of a heartbeat, elevator shafts, and anesthesia can help ease the pain of generational trauma caused by state violence.[14]

9 Spivak, "Can the Subaltern Speak?"

10 Chen, "The Stakes of *Dictee*."

11 Avery F. Gordon, *Ghostly Matters: Haunting and the Sociological Imagination* (Minneapolis: University of Minnesota Press, 2008).

12 Toni Morrison, *Beloved* (New York: Knopf, 1987); Gordon, *Ghostly Matters*, 139–42.

13 Bhanu Kapil, *Schizophrene* (New York: Nightboat Books, 2011).

14 Kim Hyesoon, *Autobiography of Death*, trans. Don Mee Choi (New York: New Directions, 2018).

Cha tells us that upon feeling through the frightening and melancholic conjuring of death, the body can disappear in a meditative trance. She rhythmically counts, recites, and lists until, with the help of her dead mother, we lift up, transcend, and finally perceive the weight of rocks, wood, and rope. The bells peal for what they are: words on paper.

O

JESSE CHUN

O

Ó

O

O. redaction of an index page from *the dream of the audience*, theresa hak kyung cha
O.
O. 시

Alongside Memory
YVES TONG NGUYEN AND TELINE TRÀN IN CONVERSATION

TELINE TRẦN

> How did you come to Cha's work? How do you continue to occupy what she preoccupied herself with in her art and writing?

YVES TONG NGUYEN

> Well, I did not end up graduating university, but I was a rhetoric major when I was in school, so I was familiar with Cha's work through communications, rhetoric, and media studies—in a similar vein to Trinh T. Minh-ha. I started revisiting her work because of the *New York Times* obituary and Cathy Park Hong's writing on her in *Minor Feelings*. These eulogistic writings reinvigorated the collective desire to revisit Cha's work, and I can't deny that I was affected by that.
>
> The way she thinks about what it is to be a migrant and her preoccupations with language are of concern to me. But I don't necessarily occupy these spaces in the same way. I came to look at her work through both a personal and critical lens.

TT

> The way you structured your talk at Wendy's Subway was critical of all the media attention and interest in her biography that was going around at the time. I remember your sharing a couple of tweets to show how the media represented her work in news outlets today.

YTN

> If you look at someone's life, work, and legacy, the circumstances of their death almost inherently inform your thinking. You can't really escape it. I expressed feeling conflicted about how people don't want to talk about her death or how she died in some effort to honor her work, or, the opposite: people only want to talk about her death and how she died, without honoring her work. I don't think that you can do justice to somebody without talking about how they died. This comes from a very personal place for me, because I am also a death doula. A lot of my organizing work in collective revolves around honoring people's memories after they pass, doing vigil work and grief work. I don't think you can separate those things. People are afraid of death or uncomfortable with it, especially deaths that are violent, deaths that are complicated and difficult. People tend to want to look away from them.

TT

> I am of the belief that the reason why people avoid talking about her death has a lot to do not just with honoring her work, but also with

avoidance itself: it comes from a place of fear, especially given the un-
expected and violent nature of her death. Yet, so much of her work has
to do with the passage of time, death, and memory. I'm thinking of one
of her performance pieces, *A BLE W AIL* (1975), where a curtain made of
cheesecloth separates the viewer and the artist. In her notes, she says,
"The affect on the viewing of the performance is that of seeing through
an opaque-transparency." She was playing with fire, water, and silence.
The audience was not allowed to cross behind the curtain, but they
could see through the cheesecloth during the whole event. Even in her
live performance work, she stated that she wished to be "the dream of
the audience."

Theresa Hak Kyung Cha, *A BLE W AIL*, performed at Worth Ryder
Gallery, University of California, Berkeley, 1978.

YTN It's difficult to reckon with someone's memory and work. She wouldn't oc-
 cupy the same place in the collective memory if she were still alive. What
 I know of her is that she was an exceptionally privileged Asian woman,
 even in the context of being a migrant. People tend to erase that. I feel that
 people do it to form a narrative, whether purposefully or carelessly.

ALONGSIDE MEMORY

TT Liberal institutions that she engaged with were a part of her life and work.

YTN She shows the dynamics of colonialism through her work, but only in
 an isolated way. Even when she brings in history beyond her personal
 or familial experiences, it could be read as not overtly political, which
 is neither good nor bad; just something to note. And as far as we know,
 when she was alive and working, her work wasn't really in dialogue
 with, or in relationship to, organizers, protestors, or radical folks who
 were also making art. It is constantly noted in writings about her that
 she was at UC Berkeley during the beginnings of the Asian American
 Political Alliance, which was involved with the Black Panthers and the

Red Canary Song's installation for the 8Lives Vigil,
Washington Square Park, New York, March 16, 2022.

 anti-Vietnam War movement, but she was never a part of that struggle.
 I found that out by reading Constance Lewallen's introductory writings
 about Cha's life and work while she was at Berkeley. She was never
 engaged in material struggle or collective action. She viewed herself as an
 artist. And even though she was an outsider, she still very much wanted

to interact with these liberal institutions, with white people, academia, and art institutions at large. That informed a lot of her work. We'll never really know if she viewed herself in this way, but if I had to hazard a guess, I would assume that she wasn't really trying to view herself in the context of the Asian American movement and collective liberation.

TT At the same time, people do try to move her legacy into discourse around liberation, which is another interesting phenomenon. In March 2023, I attended the book launch for Joy James's In Pursuit of Revolutionary Love: Precarity, Power, Communities and someone asked what she thought of Toni Morrison. James was adamant about how Morrison was not a revolutionary. She brought up the context of her funeral and how the kinds of people who were allowed to attend and mourn her, and the kinds of people who are allowed to publish her and write forewords for her books are not revolutionaries.

YTN Many people frame Cha's work in a specific way, playing into certain narratives about who she is or what her work is. Like, she's the best artist or writer you've never heard of. I want to push against that because it's just not true: many Asian Americans who are poets, writers, and artists themselves have interacted with her work for decades. She may be avant-garde but she is certainly not revolutionary. Dictee in particular resonates with a lot of people. The way she talks about herself, her mother, and her mother tongue elicits a strong reaction and identification. But then, that isn't looking at the full breadth of the work she was able to make, even though she had an exceptionally short life. And I have listened to and read a lot of Dr. Joy James's interviews, podcasts, and books, especially the ones in which she talks about identifying as an academic doing abolitionism because she is not a revolutionary organizer, and about identifying other people or spaces as different forms of abolitionism, like celebrity abolitionism. Joy James is careful about talking about herself in the context of being a revolutionary and the space that she occupies as an academic. To be able to look at other people and identify the space they occupy is something I believe she can do, because she understands how to contextualize herself and is critical of these spaces—something that I don't expect a lot of academics to do. She is very clear about the lack of revolutionary potential in these liberal institutions.

TT Joy James is great at understanding what communities she's actually a part of. Not just because someone could say she is part of a community, but because of her material participation in movement work. You're an organizer and death doula. You plan a lot of memorials. You planned a memorial recently through Red Canary Song. The organization has a lot to do not only with organizing workers, but also with addressing the legacy of migrant workers. Can you speak to the legacy of migrant worker Yang Song?

YTN We always try to honor Yang Song and talk about the fact that she died as a result of criminalization. You could talk about it very sensationally or exceptionally—she died jumping out of a window during a police raid. But even prior to that, she was subjected to a lot of violence at the hands of the police, who were blackmailing her to be an informant against her fellow workers to avoid jail time and punishment. Eventually, when they raided the place, she jumped because she could not see another way to survive. And that is not an exceptional story. So many workers do the exact same thing when the police raid their businesses. They are just trying to get away because they know that incarceration, going through the court system, and going to jail and possibly facing deportation, is a death sentence. Yang Song died as a result of police violence. We always keep that at the center of our work, which is to say we position ourselves as abolitionists and we are in opposition to the police. We are thinking about how, specifically, to create safety for workers. And that's, of course, something people have always done, something sex workers have always done, something marginalized groups have always done outside of these systems. There's only a very specific segment of people who view the police and the government as creating a type of safety, or rather, who get any safety from them. Her legacy is close to us, and we try to remember her tangibly every year. We continue to hold vigils. In recent memory, we have continued to hold vigils for the people who were murdered outside of Atlanta during the massage business shootings in 2021. We do so because we think it's important to continue to remember and honor people's memories, but also to reflect on the ways they died. We don't shy away from how they died. It's important to talk about how their lives were all-too-short because of violence, whether it be violence from an individual or from the police, which all have the same root.

TT What drives these acts of violence? I believe this drive needs to be named while you're also memorializing someone's death. Red Canary Song explicitly positions themselves as abolitionists, migrant workers, and/or advocates. They say that the democratic US imperialist state systemically targets people and therefore encourages their deaths. This is in contrast to the #StopAsianHate campaigns that have surfaced in New York City and beyond in the past three years, calling for the end of an ambiguous racial violence that seems to appear out of something as simple as falsified peak in "hate crimes." As someone who has spent time extensively in Asian American circles, I notice many of the proposed solutions to said "hate crimes" are calling the cops, increasing surveillance technology, media coverage, liberal education, and bipartisan political representation. These calls are dancing around the elephant in the room, or more so feeding it by hand.

YTN We don't want to reproduce or push a system to reproduce the violence that led to their death. For Cha, like so many people, certain forms of carcerality and narrative act as pitfalls. These carceral narratives reproduce the conditions for Cha's death and then how she was remembered or was not remembered. It's often mentioned how she was addressed immediately after her death: "She was called Oriental Jane Doe. She isn't remembered. People don't talk about her death or the violence she faced, they don't talk about her in the grand scheme of remembering Asian people who died at the hands of violence." I don't think that this rhetoric actually does justice to her or anybody else because playing into these narratives puts other people at risk. It creates an environment that facilitates conditions that lead to violence toward even more marginalized Asian women and other folks.

TT It is not enough to say that a marginalized Asian woman died.

YTN So much of how people want to remember her is wrapped up in true crime. In my workshop with Wendy's Subway, I showed instances where even her family members go on true crime podcasts and shows. The entire basis of that genre is to exploit violent and traumatic stories for entertainment, for fear mongering among the general public; it presupposes policing as the solution. Migrant Asian women and people who have less access to resources, less access to language, are hurt by specific types of violence, including police and prison violence. It's unfortunate

that people try to use her within the framework of New York City homicide and crime rates data. Buying into that kind of rhetoric only furthers the harm that people like her and other marginalized people experience.

TT I'm thinking about the desires that people have when they think of things as a crime and want to make them legible in terms of criminality. I remember in our workshops, we talked about the urgency and need to disentangle the conditions of her death. Often the scope is quite granular. You said true crime focuses on who was working that day, those kinds of details. What you're getting at is the focus of understanding her death is in the scope of the state's language and in the scope of crime data. What does it mean to just let it be without this urge to detangle? Unlike sitting in this discomfort. Does detangling aim to get legibility under the state? I'm thinking about public memorials of war and death. I think about this in the context of imperialist war and how people memorialize a veteran versus a civilian.

YTN Some of the detangling does aim to get legibility under the state. I try to push against the sort of continuous mad dash for legibility by Asian folks, especially in the past two years. A lot of Asian people are trying to be recognized under the state and under certain terms, like the hate frame Kay Whitlock talks about and urges against. People want these murders to be considered "hate crimes" motivated by race. You ask this question as if to say, "Oh, if we include her in this, it'll fix something," when I actually think that it's counterproductive. It's not to say that we shouldn't talk about her death. But why do you so badly want her death to be talked about alongside Vincent Chin's? Why do you want to talk about her death next to, say, Christina Yuna Lee's? People want the state to acknowledge that there is a wave of anti-Asian hate crimes. Of course all their deaths are gendered and racialized. How can they not be, but the comparisons feel oversimplifying and misguided to me. The state is always going to be a white supremacist apparatus. The police and prisons are arms of that apparatus. Even if they recognize the violence toward us, what will they do about it? They will em ploy and deploy more police. Theresa Hak Kyung Cha was brutally assaulted and murdered by Joey Sanza. And you know how we're going to stop it? We're going to send police into the streets. What does that lead to? Who does that really serve? It leads to, again, more migrant Asian women being assaulted and dying. We know the violence that we face. Why do you

need the government or statistics or news media sources to acknowledge what we already know? We can honor our own knowledge. I struggle with people bringing up her death in the context of the Atlanta spa shootings. People bring it up, in part, because it is a speific political moment coming out of COVID-19 pandemic narratives about rising anti-Asian violence and how "nobody talks about anti-Asian violence," an idea Red Canary Song has pushed against—that somehow the eight people murdered outside Atlanta matter more now because of the pandemic. As massage workers, they were subjected to sexualized violence stemming from the hatred of sex workers, Asian women, working class people, and immigrants; those cannot be separated from each other and cannot be compared to others, and they face that violence on a regular basis from clients, community, and the police. This experience is specific and not every Asian woman faces it. Her death and the conditions surrounding it are so different from the deaths of the Atlanta victims and from those of others who have been mentioned in the same breath as Cha, like Christina Yuna Lee or Vincent Chin. I completely reject the effort to collapse their deaths into the category of "anti-Asian violence." Cha was assaulted and murdered by a serial rapist, which is a detail I try to bring up with sensitivity as a survivor myself. Lee was murdered by a Black man, which doesn't change the tragedy of her murder, but I think it does change the way it is talked about and reported on. I won't get into it here, but anti-Blackness is rampant and often employed to increase policing. People want to disentangle only up to the point of legibility, or to be like, "Why don't we talk about this?" I always push against that question. Because who are you talking about when you say that?

TT Where are you wanting it to be talked about? Where do you see it not being talked about? There are many reasons given for these deaths and their understanding in the community. A lot of the time people don't ask themselves the question of who they want this to be talked about with. I'm thinking about your mentioning of public memorials for the war in Southeast Asia.

YTN In the field of rhetoric, public or collective memory often revolves around memorials, museums, or public monuments. The Vietnam Veterans Memorial in DC comes to mind. Obviously, I think for us as Vietnamese folks and in terms of how people remember things and the

search for legibility, for being remembered in certain ways, especially in the context of the US, memorials are never really going to do it for us. It's a veterans' memorial after all. It's painful for us in a different way. As a Southeast Asian person who doesn't support the US, I am critical toward the US and toward US imperialism, so memorializing veterans who fought for a government that didn't want to see Vietnam free and directly led to millions of Vietnamese, Khmer, and Lao deaths—I just can't stand it. But the Vietnam Veterans Memorial is quite different and gorgeous. Maya Lin—and it's also special to have an Asian architect develop the memorial—made it very different from other war memorials. The intention was for it to be a mirror, a reflective surface. When you look into it, you see yourself. It's shaped as a sharp, angular gash in the ground, a recess in the ground where it sits. I think about how people choose to remember certain types of violence in the context of the US. The Vietnam Veterans Memorial stands in contrast to that. I love that memorial. It brings up important questions in the context of violence toward Asian people, whether it be individuals, state violence, or wartime violence toward civilians and veterans. Maya Lin makes it so minimalist you have to reckon with the overwhelming amount of lives lost, and what for. To bring up a mirror to the US public.

TT That's personally interesting to me, too. I've never been to DC, and I've always wanted to see it. You're saying it's like a gash in the ground, like a recess you walk under to go see it.

YTN It's built like a giant V cut into the ground where they placed it. I remember Maya Lin saying she felt like the V also represented open hands. She hoped that it would heal the wound opened by the war in Southeast Asia. War memorials that existed prior to this were usually statues of soldiers, very classical. People were conflicted when it was first revealed. It was architectural, a structure essentially meant to signify a wound or a thorn on the side of the US, which I would argue the war in Southeast Asia is. Even if people don't acknowledge how wrong imperialism is, most people in the US would say that the Vietnam War was a regret—that the war in Southeast Asia was a regret for the US. That's what lends itself to this memorial. What is it to look at somebody's life and anticipate their death? Is it like looking into a mirror? I don't know that it fully is, but it certainly is meant to shine a mirror back on you. People reflect and project themselves onto any type of monument.

The Vietnam Veterans Memorial reflects us back; it reflects exactly what the state wanted or what the people wanted out of it, as well as what the people who built it wanted out of it. It's a grand gesture built around violence to inform us of state desires. While it's not a war memorial, the 9/11 Memorial and Museum does the same thing: it's built to make you believe certain things, what the government wants you to believe in—the US as a moral authority and the legitimacy of US interventionism—similar to how some museums are made to reify certain objects and legacies.

TT I'm thinking about how war is justified, what it looks like when some-one dies for war. That's what the memorial evokes. Memorials have a process: a strategy and a goal for what the person needs to think about. If the US state has the logic down, then we can think of US memorials critically in that way. Why can't we extend that to the way that people talk about piety for the dead or martyred?

YTN Cathy Park Hong's *Minor Feelings* works as a memorial. You want Cha to be remembered, you want her to be talked about, and you want to ask certain questions about her death. And I would ask whether the way that you do it achieves your goals. We all have different goals, values, and principles, so it requires some personal reflection, but if the goal is for white supremacist violence or gender-based violence to end, legitimating crime data and narratives around crime waves isn't going to do it. That's a question that we ask ourselves in Red Canary Song. Are we in alignment with our values and goals? We've built memorials, we've built physical art installations. It's part of what we do, to varying degrees. The most recent one people often think about is the memorial/art installation we created, in honor of the eight people—Delaina Ashley Yaun, Xiaojie Tan, Daoyou Feng, Paul Andre Michels, Hyun Jung Grant, Soon Chung Park, Suncha Kim, Yong Ae Yue—who were killed in the Atlanta spa shootings. In this art installation, we built massage beds that took the shape of ancestral altars and were built by massage workers in our collective—Lisa, Charlotte, Lynn, and other members. We were very intentional with how we built it, what we used to build it, and the items we placed on it. The construction and materials, for instance, have a specific signification. Another member of our collective, Chong Gu, conceptualized most of it by building upon the symbology Red Canary members have been utilizing and bringing into spaces, such as ances-tral altars, which many members use in their own spiritual practices to

honor the dead. The sheer curtains harken back to actual curtains used in massage businesses in Flushing; they are not only used as decoration but also for privacy and separating spaces, acting as makeshift walls. We thought about how people might interact with them. The paintings hanging on the outside were painted by a migrant Korean massage worker, and we wanted them to generally be eye-level, so people would look into the eyes of the dead. Those are just a couple of examples of what went into our thought process behind it.

When you start talking about someone like Cha, you inscribe certain things into the collective memory of someone's death. That is very much the work of memorialization; even when you are not physically building a memorial, you are building something material that lives alongside memory.

Yves kneeling in front of the vigil installation.

ALONGSIDE MEMORY

Wu (left), Sunmi (center), and Yves (right) kneeling in front of the vigil installation.

YVES TONG NGUYEN AND TELINE TRẦN

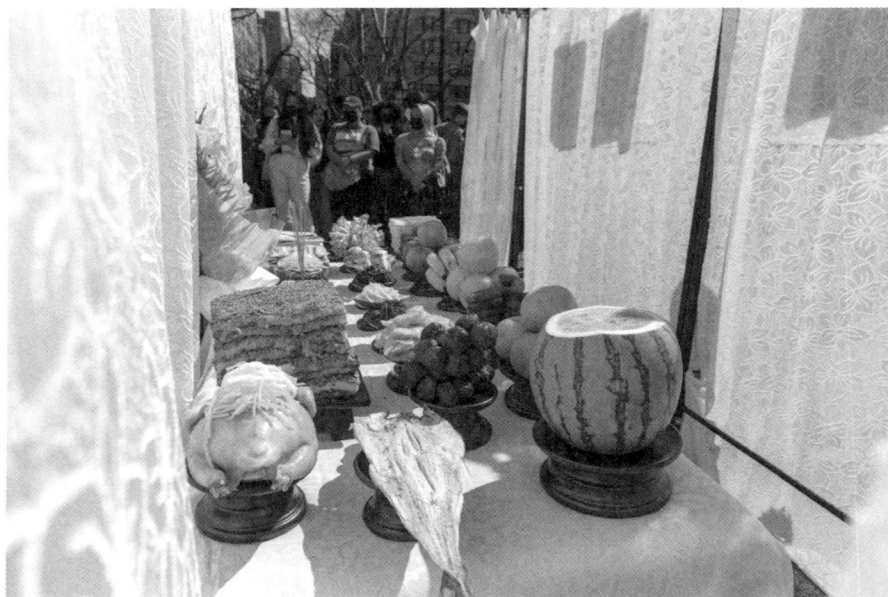

Inside view of altar with food, built on a massage bed.

ALONGSIDE MEMORY

Theresa Hak Kyung Cha's Dictee and Notes toward a Practice of Criticism

UNA CHUNG

As Theresa Hak Kyung Cha's work receives a new wave of attention with substantial mention in Cathy Park Hong's memoir *Minor Feelings*, Wendy's Subway's seminar and screening series (the occasion for the writing of this essay), and the Whitney Museum's inclusion of Cha in a prominent place within its 2022 Biennial, I find myself ruminating anew on an old question: *What is the purpose of criticism today?*

In his essay, "Is Art Lighthearted?" Theodor Adorno counters critics' favoring of serious, socially committed, realist art with the popular audience's need for vitality-enriching lighthearted respite from hard labor. Adorno is not simplistically endorsing escapist fantasy so much as pointing out that there can be no easy opposition of high and low art, if we take into consideration the transmission of *affect* by an ordinary reader as well as the interpretation of representation by a specialist. To take this line of thinking a step further in a direction that is not Adorno's own: can the activity of criticism be understood as a *practice of mind* (a type of meditation or mind training, if you will) that moves us toward a lightness of meaning distinct from conventional academic preoccupations?

Dipesh Chakrabarty's investigation of the historiographical dilemma that besets the writer of minor histories is instructive here.[1] Chakrabarty notices the ways in which the demands of historiography compel the writer to make assertions on behalf of a subject that cannot be in alignment with the subject's own claims. The disenchantment of the natural world and the secularization of divine agency into revolutionary agency make for good minor histories but foreclose the future of

1 Dipesh Chakrabarty, *Provincializing Europe: Postcolonial Thought and Historical Difference* (Princeton, NJ: Princeton University Press, 2000).

those very vital life possibilities preserved into a dead past. As these stories pass into written archives, there is a cost. It is not simply that representation without affect is sterile (to cite the psychoanalytic insight) but that good representation can obscure or destroy living affect.[2] Chakrabarty's essay is sobering, for he does not object to erroneous scholarship or individual bias; instead, it is the incontrovertible foundation of historiography which he targets: sanity, rationality, legibility. How could we possibly do without these? Despite the paradoxical challenge facing historians of subaltern studies, an ordinary reader remains free to *be affected* in whatever way, including the possibility of experiencing life-changing effects, as well as, say, simple boredom. It may be that the work of decolonizing the field of literature is realized more easily outside of the purview of a field.

In *Blindness and Insight*, Paul de Man describes developmental stages of reading in order to explain how the activity of criticism actually emerges, rather than rely on categorical differences among author, reader, and critic to describe different types of activities.[3] As one *writes* one's reading, the first blind reader (author) is retroactively projected by the writer, then supplanted by a second naïve reader (reader) and finally captured as the insight of the third critical reader (critic). The critic writes into being a composite of these three figures whose developmental progress can be narrated as the arrival of a new insight into a text. This developmental schema proposes stages of a path of criticism and the practitioner's journey as the purpose of criticism itself. If I may be permitted an unusual comparison, I would like to propose that just as meditation practitioners use discursive thoughts not to represent insights to themselves but to directly grasp the moment of experience itself, reader-critics too may use a text not in order to decipher the meaning contained within the words but to encounter insights arising from the totality of their minds/lives. Returning to Theresa Hak Kyung Cha's *Dictee*, I would like to raise a *practical* question about it means to read, or write criticism about, *Dictee: given the presence of so many gaps in the text, what is that experience of a gap good for?* Theoretical interpretations of *Dictee* tend to add heavy layers of meaning onto a text that appears quite deliberately sparse. As reasonable as it seems to address Korean history, colonization, exile, migration, and war as ways of providing context for a new reader of *Dictee*, there lies a hidden danger in leaving unexamined the very assumption that *Dictee* must hold historical and specifically ethnographic value. It may seem quite natural for the critic to *fill in the gaps* noticed by the naïve reader

2 Bruce Fink, *Lacan to the Letter: Reading* Écrits *Closely* (Minneapolis: University of Minnesota Press, 2004).

3 See Paul de Man, *Blindness and Insight: Essays in the Rhetoric of Contemporary Criticism* (New York: Oxford University Press, 1971).

of the text and initially constructed by a willfully blind (-folded) author (a common image from Cha's performance art); it may even seem to be the critic's task to flesh out narratives about nation, ethnicity, and gender by way of a type of literary construction which *Dictee* itself abjures. However, are we not then in danger of losing the *gap* itself?

It bears repeating in this context, and seems necessary always, to historicize the self-naming of Asian-America in 1968, as well as the formation of sociology as a discipline in the US, consonant with the rise of American empire in the early-twentieth century. The importance of ethnographic authorship to both the social sciences and the new conceptualization of ethnic (*naturalized* or racialized) citizenship led to the development of a notion of identity that was a necessary precursor to the 1968 moment of Asian-American self-determination.[4] Using the name of Asian America (which lost its hyphen sometime in the mid-1980s) to refer to a pre-1968 history strengthens the coherence of the sociological concept, even as it threatens to make less visible the tenuous connections within and between lives contained in its pre-history. Given the contradictory nature of the Chinese Exclusion Act (1882) and the Immigration Act of 1924, Asian America was always fated to become a minority presence as a sign of the desire for its very absence: a representation of the American unconscious that, at times, covertly appears as a mysterious sign of purportedly Asian affects. The Asian American *timeline* was thus constructed as a symbol of a very particular kind of gap in the *history* of nation. By 1996 Susan Koshy would call the rubric of Asian America a *fiction*, as its post-1975 future proved to be no less troubled in referential coherence as its pre-1968 past.[5]

On the other hand, the hauntological notion of an *Asian affect* can never provide an alternative starting point. Ever since Edward Said's *Orientalism* appeared in 1971, we have never again been able to believe that *mere being* could be easily retrieved from within or without the Orientalists' archives (other than through poetry perhaps, as Said is himself borrowing Wallace Stevens's phrase), nor that realist narrativity, whether in the social sciences or in literary criticism, would be the vehicle for accomplishing such a desire. The reader/critic of Orientalism learns to

4 See Karen L. Ishizuka, *Serve the People: Making Asian America in the Long Sixties* (London: Verso, 2016); Cynthia Tolentino, *America's Experts: Race and the Fictions of Sociology* (Minneapolis: University of Minnesota Press, 2019); Henry Yu, *Thinking Orientals: Migration, Contact, and Exoticism in Modern America* (New York: Oxford University Press, 2001).

5 Susan Koshy, "The Fiction of Asian American Literature," *The Yale Journal of Criticism* 9, no. 2 (Fall 1996): 315–46.

look for—*and not find*—both the East and the absence of the East, its existence and non-existence. The experience of a glimpse of emptiness, in the Buddhist sense, is precisely this type of seeing-and-not-finding, which has also been described as the experience of a fullness of presence. Might the postcolonial writer (which we all are, students, teachers, readers, and critics alike) start *here*, with this insight into a practice of mind that can directly feel the power or life-potential of the absence (but better to say *emptiness*) of that which racism sought to ensconce in its archives, its text? Let us acknowledge, for just a brief moment, the critic's initial sense of loss in this moment of dissolution, before turning cheerfully toward the vanishing of the delusion of the East made possible by methods of decolonization (among which I would include Buddhist mind training). Let us not re-name the East in yet another repetition of a fantasy of realism, and instead begin with the lightest of words, a singular indeterminate article—*a*—or an image of an open mouth, such as appears in Cha's *Mouth to Mouth* (1975).

Rather than succumb to the "ethnological temptation" yet again (to borrow a phrase from Roland Barthes), perhaps we might consider experimenting with a different kind of criticism appropriate to what Patricia Clough calls the "ends of ethnography"—calling attention both to the purpose of the field of sociology and its decline (in literary study at least)?[6] It may be that *Dictee* was already a part of both kinds of *ends* of ethnography in 1982, even as the publishing industry was just starting to gear up to boost its Asian American memoir section. We should not be surprised to discover that some of these texts hold strange tales (rather than *good* minor histories) that do not at all bolster the ethnic subjects of Asian America, or, as Cathy Park Hong decries, ignore an important death.

For Clough, what ends ethnography is the exhaustion of realist narrativity itself as a privileged source of knowledge. To answer the question of what an autobiographical text can do other than ethnologize reality, Clough turns in her next book, *Autoaffection*, to the operations of the technical substrates of unconscious desire in verbal expression. Rather than a psychoanalytic analysis of a text, revealing its subtextual or contextual meaning, criticism might confront head on its own entanglement with realist narrativity and do something else—that is something, well, *lighter*.

6 Roland Barthes, *Roland Barthes by Roland Barthes,* trans. Richard Howard (Berkeley: University of California Press, 1977), 84; See Patricia T. Clough, *The End(s) of Ethnography: From Realism to Social Criticism* (Newbury Park, CA: Sage, 1992).

I wonder whether Cha was not doing something just a little bit different from other poststructural thinkers of her time. She was well-read in European film theory and had published a book called *Apparatus*, which contained her own physically proximate set of pages printed in the center (crease) of the book, which cannot be said to contain or not contain references to the essays it anthologizes. Cha's centerfold pages provoke, for me, the *aesthetics of gap* (vis-à-vis concatenation of meaning via narration) or *space* (without reference point)—abruptness, surprise, tactility, spontaneity, intimacy, immediacy, unconditioned, indeterminate—which are replete in any experience of reading/looking at *Dictee*.

Meditators come to know gaps as transient glimpses of space that arise when the noisy commotion of a text (or our own mental voices) settle. Gaps are the space from which utterance occurs—not the false universal of everyday language or the habitual reactions of so-called common sense, but a different kind of space: just space.[7] *A free utterance* is a gap. Our minds can make any set of words (and gaps) link together into enchained narratives of nation and gender (or whatever), but such articulations may fail more frequently with the development of meditation practice. To a trained mind, Benedict Anderson's imagined community may fail to appear in favor of a different kind of visualization—a personal discovery from a sacred past of what makes us primordial, spontaneous, indigenous to space itself.

Dictee gives us aesthetic renderings of the gap in so many ways—fragments, brevity of articulation, high ratio of punctuation to words, use of blank space on the page, lists, images, etc.—with the effect of interrupting the mind's habitual motor of concatenation. A reader might meet the praxis of criticism—recognition of affect arising in the dissolve of representation—anywhere in *Dictee*, with a manual flip through the pages of the book. *Dictee* gives us a way to establish not a new *value* for the notion of the gap but an entirely different *basis* for considering the question of gaps altogether. Not a new name but a new beginning for *practice*.

At the end of ethnography, then, we may discover ourselves in a bardo where the utterance of one who knows herself not as the object of her own, subjective self-knowledge, but through *a non-dual knowing*, which tells us that we have lost our name but no longer feel lost. The bardo is often described as a tiny island

7 The court case of Bhagat Singh Thind v. USA reveals the true meaning of everyday and common sense in the ruling's deference to the so-called ordinary definition of whiteness over the scientific definition of "Aryan."

in the middle of a river, a no-man's-land; one moment has ended and the next has not arrived. Yes, after Asia, but always before America. *Dictee* is ruthlessly lighthearted—empty and luminous, free from nation, free from home, *a. Dictee* may start by telling a story about liberation but gets lost/awoken in the samadhi of looking at the telling, breath by breath, word by word, mark by mark, space by space. *Dictee* gives not a manifesto by the Third World woman but hears her naked breath.

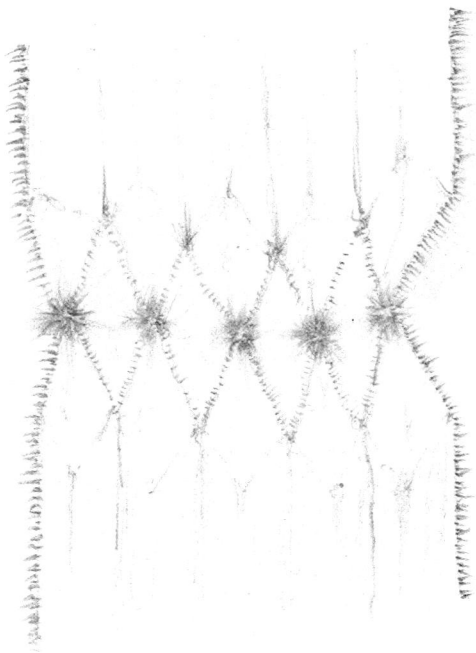

The Diabolic Dictée
SOYOUNG YOON

Carl Theodor Dreyer, dir., *The Passion of Joan of Arc*, 1928 (still).

First Friday. One hour before mass. Mass every First Friday.
Dictée first. Every Friday. Before mass. Dictée before. Back in the study hall.
It is time. Snaps once. One step right from the desk.
Single file. Snaps twice. Follow single line. Move all the way to
the right hand side of the wall. Single file. The sound instrument
is made from two pieces of flat box-shaped wood, with a hinge at the cen-
ter. It rests inside the palm and is snapped with a defined
closing of the thumb.[1]

Passions still run high, we are told, about the pedagogical necessity of the *dictée*, whereby the student must write down literary passages that the teacher reads aloud—a daily spelling and grammar test that has been implemented in French elementary classrooms since the nineteenth century.[2] The difficulty of the French dictation test, and its reputation as a thing of dread—not so much an exercise

1 Theresa Hak Kyung Cha, *Dictee* (Berkeley: University of California Press, 2001), 18.

2 See, for example, Ann Beer, *"The Dictée in Multilingual Contexts: Exploring Literacy Memories Across Cultures,"* *Sociolinguistic Studies* 1, no. 1 (2007): 157–61.

as a rite of initiation—are due in part to how much spelling and grammar are intertwined in the French language. Correct spelling of a word is contingent upon comprehending its meaning in the context of the selected passage. Reporting in the 1980s on the cultural phenomenon of the then-new national dictée contests, the journalist Stanley Meisler, foreign correspondent for the *Los Angeles Times,* notes how the particularities of the French language turns the dictée into a puzzle, even a trap.[3] He cites the scandal of Prosper Mérimée's "diabolic dictée" for the court of Napoleon III in 1868 (the emperor made forty-five mistakes), as well as the televised national finals in 1986, watched by millions with both bated breath and pencil and paper in hand, where "contestants could not figure out how to spell one adjective pronoun in the first sentence until discovering six lines later that the person talked about was a woman."[4] And as much as the dictée is a source of dread, it also produces shame: a singular and intense shame about the bad spelling of one's mother tongue. As Theresa Hak Kyung Cha's *Dictee* suggests, it is an experience of shame akin to the rite of confession. The opening chapter of Cha's book moves back and forth from the calls and responses of French language exercises to that of Catholic rites of mass, which seek to interpellate the body of the individual, shaping her mouth, her lips, her throat, her breath—and her mind, her fitful experience of herself as a "self"—into the subject who speaks:

> Q: WHO MADE THEE?
> A: God made me.
> To conspire in God's Tongue.[5]

The subject does not so much speak as is spoken.

Through the discipline of the dictée, there is a particular effort to harmonize the French tongue and ear, the rhythms of the printed word and the flow of handwriting, the literary and the bureaucratic, the public and the private, into one, seamless flow of the mother tongue. The first dictées were administered as tests for civil servants under Napoleon I. The dictée would enter classrooms a few years later as a tool for shaping, standardizing, and nationalizing the French language amid highly politicized attempts to modernize the French education system—the state battling with the Catholic church over the control and reach of public education.

3 Stanley Meisler, "Dreaded Dictee: French Test Puts Accent on Perfection," *Los Angeles Times*, December 21, 1987.

4 Ibid.

5 Cha, *Dictee,* 17.

THE DIABOLIC DICTÉE

The dictée, then, could be described as one of the cultural techniques that the media theorist Friedrich Kittler claimed as constituting the "discourse network" of the 1800s: changes in the practices of language acquisition, tied to bureaucratic reform, which were part and parcel of the changes in the formation of the family and the nation state, the divisions of labor across private and public spheres, according to which women were inscribed within the private sphere of the family as the primary caregivers—and teachers—of children.[6] Mothers would teach children how to speak, and more importantly, the *desire* to speak, recoding the noise of the child's babble as that which could be interpreted as the nascent speech of an inner voice, a soul, or a spirit. Language would be perceived as deriving from the desire of—and for—an originary orality: the mother's voice. "And when later in life children picked up a book," Kittler adds, "they would not see letters but hear, with irrepressible longing, a voice between the lines."[7] "We are dealing with nothing less than the discursive construction," Geoffrey Winthrop Young encapsulates, "of that particular type of intimate, eroticized motherhood which 100 years later will be excavated by [Sigmund] Freud and presented as a near-universal constant."[8] Through the dictée, we would learn not only a language but also the "Mother Tongue."

<p style="text-align:center">*</p>

In Cha's *Dictee*, now considered a part of the canon of Asian American literature, there is a deconstruction of this ideology of the mother tongue and its accompanying fantasies of the maternal, nativeness, naturalness, and presence, especially by foregrounding the technicity of its learning. Learning begins with mimicry: "She mimicks [sic] the speaking. That might resemble speech. (Anything at all.) Bared noise, groan, bits torn from words."[9] The acquisition of language becomes the shaping of breath, as well as the falling away of breath; there is the pain of hesitation, of doubt, of self-censorship, the pain of a censorship that begets a self that turns ever against itself: "In preparation. It augments. To such a pitch. Endless drone, refueling itself. Autonomous. Self-generating."[10] In particular, there is an excessive and

6 Friedrich Kittler, *Discourse Networks 1800/1900*, trans. Michael Metteer, with Chris Cullens (Stanford, CA: Stanford University Press, 1990).

7 Ibid., 34.

8 Geoffrey Winthrop-Young, *Kittler and the Media* (Cambridge, UK: Polity Press, 2011), 33.

9 Cha, *Dictee*, 3.

10 Ibid. See, especially for discussion of *Dictee* in relation to editing of Cha's film *Permutations* and the repetition-compulsion of the death drive, Soyoung Yoon, "Majestic Necessity," in *Whitney Biennial 2022: Quiet as It's Kept* (New York: Whitney Museum of American Art, 2022), 259–65.

emphatic deployment of punctuation—as in the editing of Cha's film *Permutations* (1976)—through which the line of a sentence starts and stops, starts and stops, over and over again, like the abruptness of the snaps that beat out time, beat out directives for when and how to move, how to kneel, how to believe: "Back in the study hall. It is time. Snaps once. One step right from the desk. Single file. Snaps twice. Follow single line."[11]

For the reader, the force of Cha's *Dictee*, I'd argue, lies in part in this deployment of punctuation, which mimics the grip of the mother tongue over the body—and over the body politic. How to speak when to speak is to find yourself as if at a confessional, an interrogation booth, a court of law, or a border? How to speak when language is bound up by laws and rules and customs, the technicalities of which you are all too liable to—even destined to—trip over, as if the line of a sentence were a minefield, like the arbitrary line of the 38th parallel, become sacred, through war, through ideology, as the world's most heavily fortified border? How to speak when to speak is to be found out?

Later in Cha's *Dictee*, in a chapter that begins with an illustrated map of the two Koreas, the sharp cracking sounds of the aforementioned snaps find a deadly resonance in the sudden breaks of silence amid the roar of a crowd in revolt—and the repeated violence which will be deemed necessary to fortify the arbitrary line of the 38th parallel as a sovereign border, a border as sacred and inviolable as the laws and rules and customs that seek to guard the mother tongue against its othering:

> I feel the tightening of the crowd body to body now the voices rising thicker I hear the break the single motion tearing the break left of me right of me the silence of the other direction advance before...They are breaking now, their sounds, not new, you have heard them, so familiar to you now could you ever forget them not in your dreams, the consequences of the sound the breaking. The air is made visible with smoke it grows spreads without control we are hidden inside the whiteness the greyness reduced to parts, reduced to separation. Inside an arm lifts above the head in deliberate gesture and disappears into the thick white from which slowly the legs of another bent at the knee hit the ground the entire body on its left side. The stinging, it slices the air it enters thus I lose direction the sky is a haze running the streets emptied I fell no one saw me I walk. Anywhere. In tears the air stagnant continues to sting I am crying the sky remnant the

11 Cha, *Dictee,* 18.

gas smoke absorbed the sky I am crying. The streets covered with chipped bricks and debris. Because. I see the frequent pairs of shoes thrown sometimes a single pair among the rocks they had carried. Because. I cry wail torn shirt lying I step among them. No trace of them. Except for the blood. Because. Step among them the blood that will not erase with the rain on the pavement that was walked upon like the stones where they fell had fallen. Because. Remain dark the stains not wash away. Because. I follow the crying crowd their voices among them their singing their voices unceasing the empty street.[12]

The 38th parallel is materialized as two movements of bodies—the movement of the people and that of the state, the movement of the student protestors in uniform and that of the soldiers also in uniform, the movement of brother-martyr and that of soldier-brother, of brother against brother—and their movement toward and against each other each become the destination of the other, as if destined for each other. And it is through the repetition of "Because," its relentlessness, and its relentless assumption of self-evident necessity—amid the breaking up of bodies, the breaking down of sentences, the tear gas, the gun shots, the tears, the blood—that Cha underscores the tragedy of how that arbitrary line has been held, continues to hold.

History as Destiny, the story of an end foretold. The chapter is titled "Tragedy," dedicated to the muse Melpomene. The above scene of the demonstration is included in a letter that is addressed to "Mother," from Seoul, Korea, on April 19, but "eighteen years later."[13] Dates such as April 19 are significant—the numbers 4-1-9 become a proper name ("Sa-Il-Gu") —in the history and collective memory of modern Korea. They are important for revolution; for the student protests that brought down the authoritarian and corrupt government of the First Republic in the Spring of 1960, on the eve of the Global Sixties; and for the image of the student protestor-as-martyr, a high school student, still a child, whose body was fished out of icy cold waters, a month after his disappearance, with a tear gas grenade lodged in his right eye. And yet, as the narrator of *Dictee* repeats, "Nothing has changed, we are at a standstill."[14] Despite the fact that decades have passed, nothing has changed. The year is 1980, and the narrator moves from the demonstrations against the 1961 military coup to the demonstrations against the 1979 coup, which would culminate in the Gwangju Uprising: "I am in the same crowd, the same coup, the same revolt, nothing has

12 Ibid., 81–82.

13 Ibid., 80.

14 Ibid.

changed."[15] Despite the fact that the narrator has returned from afar, now speaking another tongue, a second tongue—"This is how distant I am. From then. From that time"—nothing has changed: "They take me back they have taken me back so precisely now exact to the hour to the day to the season in the smoke mist drizzle ... "[16]

<p style="text-align:center">*</p>

> Learning to speak is not the same as learning another language. It would be misleading to assume that young children are involved in an act of translation; words are not merely translations of sounds, so what is translated?[17]

> I write. I write you. Daily. From here. If I am not writing, I am thinking about writing. I am composing. Recording movements. You are here I raise the voice. Particles bits of sound and noise gathered pick up lint, dust. They might scatter and become invisible. Speech morsels. Broken chips of stones. Not hollow not empty. They think that you are one and the same direction addressed. The vast ambiant [sic] sound hiss between the invisible line distance that this line connects the void and space surrounding entering and exiting.[18]

The opening to Daniel Heller-Roazen's *Echolalias* returns us to the noise of the child's babble. If the babble appears to anticipate the sounds of all the languages to come, Heller-Roazen also insists on the fundamental difference of babble from language. He references the linguist Roman Jakobson and his observations on the infant's limitless phonic capacity, a capacity to articulate any and all sounds, far exceeding that of the most gifted of polyglots: "A child, during his babbling period, can accumulate articulations which are never found within a single language or even a group of languages—consonants of any place of articulation, palatalized and rounded consonants, sibilants, affricates, clicks, complex vowels, diphthongs, etc."[19] There is a gap, however, between the infant's babble and the child's first words, a specific loss

15 Ibid., 81.

16 Ibid., 85.

17 Adam Phillips, *The Beast in the Nursery: On Curiosity and Other Appetites* (New York: Vintage Books, 1998), 51.

18 Cha, *Dictee*, 56.

19 Roman Jakobson, *Child Language, Aphasia, and Phonological Universals*, trans. Allan R. Keiler (The Hague, Netherlands: De Gruyter Mouton, 1968), 21.

THE DIABOLIC DICTÉE

of memory, a "phonic amnesia," which precedes the first acquisition of language.[20] Why would such a loss of capacity, of memory, be necessary for the child to learn to speak? For Jakobson, children learn to speak as they learn the value of speaking, more precisely, the value of communication; children learn to speak as they desire to communicate with others, and such desire comes at a cost, a "deflation": "In place of the phonetic abundance of babbling, the phonemic poverty of the first linguistic stages appears, a kind of deflation which transforms the so-called 'wild sounds' of the babbling period into entities of linguistic value."[21] Maybe the price, Heller-Roazen continues, is one of citizenship: "Perhaps the loss of a limitless phonetic arsenal is the price a child must pay for the papers that grant him citizenship in the community of a single tongue."[22]

What are the stakes of trying to remember the babble? Heller-Roazen underscores the years of war from 1939 to 1941 and the condition of exile in which Jakobson found himself drawn to the richness of the babble before acquisition of the mother tongue. From the space of exile, then, of being expelled from not only one's native country but one's mother tongue, we question the very grounds upon which such claims of nativity are placed, for to speak any language at all is to be in exile from that babble. And Heller-Roazen proposes the possibility of hearing the echo of the infant's babble, across the chasm, in the languages of adults: "an echo, of another speech and of something other than speech: an echolalia, which guarded the memory of that indistinct and immemorial babble that, in being lost, allowed all languages to be."[23]

Perhaps we can also propose, via Cha, not the forgetting of the mother tongue (or the learning of another tongue) but a different relation to it and to Mother:

> *Q: WHO MADE THEE?*
> *A: God made me.*
> *To conspire in God's Tongue.*
> *Q: WHERE IS GOD?*

20 Daniel Heller-Roazen, *Echolalias: On the Forgetting of Languages* (New York: Zone Books, 2005), 11.

21 Jakobson, *Child Language*, 25.

22 Heller-Roazen, *Echolalias*, 11.

23 Ibid., 12.

A: God is everywhere.

Accomplice in His Texts, the fabrication in His Own Image, the pleasure the desire of giving Image to the word in the mind of the confessor.

Q: GOD WHO HAS MADE YOU IN HIS OWN LIKENESS.

A: God who has made me in His own likeness. In His Own Image in His Own Resemblance, in His Own Copy, In His Own Counterfeit Presentment, in His Duplicate, in His Own Reproduction, in His Cast, in His Carbon, His Image and His Mirror. Pleasure in the image pleasure in the copy pleasure in the projection of likeness pleasure in repetition. Acquiesce, to the correspondence. Acquiesce, to the messenger. Acquiesce, to and for the complot [conspiracy] in the Hieratic tongue. Theirs. Into Their tongue, the counterscript, my confession in Theirs. Into Theirs. To scribe to make hear the words, to make sound the words, the words, the words made flesh.[24]

Confession becomes a matter of editing, of image-sound relations, of matching image to sound, of selecting from a possible array of images the right image to the sound, to the word. There is the play of free association in relation to the word "likeness." What would such a likeness be? Is it like a cast, as in the pouring of metal into a mold; is it a carbon as in the pressing of pigment onto paper; is it a mirror as in the reflection and refraction of light. How IS a word made flesh? And amid this free association, as He becomes Them, there is not only pleasure in excess of the discipline of confession, but also distraction and an excessive play of words: there is poetry, there is noise, there is babble.

An earlier version of this essay was published in the Harun Farocki Institut's online journal *Rosa Mercedes*, no. 4, May 13, 2022, https://www.harun-farocki-institut.org/en/2022/05/13/the-diabolic-dictee/.

24 Cha, *Dictee*, 17.

Theresa Hak Kyung Cha, *Mouth to Mouth*, 1975 (still).

How to Silence: On Apparatus *and* Dictee
ANTON HAUGEN

Systematic overthrow of the underclass,
Hollywood conjures images of the past[1]
— Prince

1 Prince, "The Future," in *Batman* (Warner Bros, 1989).

ANTON HAUGEN 227

Alluding to a curative path from his diagnosis of technology's effect on society, Martin Heidegger concludes his "Question Concerning Technology" with a couplet by Friedrich Hölderlin: "But where danger is, grows/ The saving power also."[1] The text suggests this "saving power" is found not in technology's rejection but within and through its dangers. Two branches appear on this path as limits to a spectrum: one where technological valuation is exclusively embodied, and another, in which these values are held at objective distance. Nam June Paik's series *TV Buddha* evokes the latter by positioning a statue of Buddha before a camera and television that displays the statue's real-time image. Buddha's enlightenment becomes an ideal of spectatorship, an existence both in and outside the floating world of technological reflection. The work of Theresa Hak Kyung Cha, however, problematizes this ideal; the silence of spectatorship is less akin to enlightenment than to death.

Cha's editorship of the film theory reader *Apparatus* presents a critique of technological interpellation that inverts *TV Buddha*. Within the reader's paratextual choices lurks the idea of a spectral double, a ghost-like manifestation of intimate fantasy that obscures and calcifies the present. Throughout *Apparatus,* Cha strews recontextualizations of proto-cinematic quotations: Plato's allegory of the cave and Diderot's Enlightenment revision lead to a fiction by Apollinaire depicting desire-based image addiction. An excerpt from Balzac's *Cousin Pons* suggests that just as a daguerreotype can extract the soul, the future can be gleaned from history's traces. Of these quotations, the last and longest is also the most glaringly uncinematic. In the excerpt from Henry James's "Jolly Corner," the protagonist faints when confronted by a materialization of an imagined self, borne from his fantasy of an alternate life. In place of editorial commentary, Cha employs small, centered images throughout the reader. To introduce Jean-Louis Baudry's essay "Apparatus," a lithograph demonstrates Pepper's Ghost, an effect in which, through projection, an offstage actor appears as an onstage ghost. Although stills from Carl Theodor Dreyer's *Vampyr* (1931) famously encircle Cha's own contribution "COMMENTAIRE," *Vampyr* makes its first appearance at the conclusion of *Apparatus'* initial essay, implying a larger paratextual thread.[2]

1 Martin Heidegger, *The Question Concerning Technology*, trans. William Lovitt (New York: Harp er Perennial, 2013), 42.

2 Theresa Hak Kyung Cha, ed., *Apparatus: On Cinematographic Apparatus* (New York: Tanam Press, 1981), 7.

"COMMENTAIRE" reduces cinema to its Manichean essence with rhythmic black-and-white pages on which the title is mechanistically deconstructed alongside allusions to time's passage. At the climax of *Vampyr*, the hero faints and dreams. He walks as a spirit through an alternate timeline, a future in which he has failed. He sees his own body, a corpse, and the film assumes its perspective. "COMMENTAIRE" disrupts *Apparatus'* design by opening with a full-page still from this vantage; the vampire stares through the coffin's glass, into the camera, to the spectator and reader. The poem concludes with the corpse's returning gaze in standard format.[3] Two other full-page photographs situate the text's use of black-and-white pages, a time-lapse of a drive-in and another of a cinema. Through extended exposure, the projected films are reduced to an ominous white. In the latter's foreground, a moviegoer sleeps across balcony seats, held by the spectre of his own hand.[4]

In *Dictee*, cinema's capacity to immobilize bodies through the mediation of history becomes the paralysis brought on by postcolonial trauma. "Clio History" depicts Yu Gwan-sun reciting "the name of Jeanne d'Arc three times,"[5] but this Jeanne and thus Yu are later subsumed in the novel by Dreyer's image of the weeping martyr.[6] As an attempt to rectify this erasure, "Clio" contrasts Yu's martyrdom with those found in film:

> Time fixes for some. Their image, the memory of them is not given to deterioration, unlike the captured image that extracts from the soul precisely by reproducing, multiplying itself. Their countenance evokes not the hallowed beauty, beauty from seasonal decay, evokes not the inevitable, not death, but the dy-ing.[7]

Like the Christian Metz critique featured in *Apparatus,* which concerns communal wish fulfillment in cinema's willful sleep,[8] to describe a session of film viewing, Cha opts for the French *"séance,"* a word that in English refers only

3 I would like to acknowledge my gratitude and debt to Professors Soyoung Yoon and Una Chung, whose talks during The Quick & the Dead Seminar, "Through the Screen: Mouth to Moving Image," set the germ for this essay.

4 Theresa Hak Kyung Cha, "COMMENTAIRE," in *Apparatus*, 261–328.

5 Theresa Hak Kyung Cha, *Dictee* (Berkeley: University of California Press, 2009), 28.

6 Cha, *Dictee,* 119.

7 Ibid., 37.

8 Christian Metz, "The Fiction Film and Its Spectator: A Metapsychological Study," trans. Alfred Guzzeti, in *Apparatus,* 385.

to contacting the dead.[9] The novel however *détourns* Metz's theories on willful immobilization by juxtaposing them to a map of divided Korea. Cinema's dream thus becomes the seductive recursion of post-traumatic alienation, "the illusion that the act of viewing is to make alteration of the visible."[10] Of vital import is "to name it now so as not to repeat history in oblivion."[11]

9 Cha, *Dictee*, 149.

10 Ibid., 79.

11 Ibid., 33.

Two Lines / Arc
JED MUNSON

for O, after Cha

-

Rove,
round of lefts, the lifted panoramics
in a sky of rooves,
 pots of potted resources
stacked—re
turning
the cluster-shamble brace to the luminary long
unfastened—

 the
evergape
 in residence. Air—
signs
hand off the scurry to the citybound
cloth,

 a clothbound stain held in no
one—
Could be light anywhere,
the fade to
 and from the invisible changing
cloaks, fade of shade, turning
points
to fades of habitual seeming.
 Cutoffs
become a center's
marked
substitution,
 unpowered courts sport
 plans for fissions
Once
, shades regulated stenciled
Wind

since vacated
for a crimped
net
,
a forced subvention

exposing
 What
 is withheld against, but the
guess at
tracked rotation, the unmade unit—the estuary
heading for a speed to settle into
the nearness of
the end of—
 Any

 thing, tiers of grass shoot
 likenesses, maybe ringed
in the silence of the vowel
wrung in half.
 Part-

part of a fixture
built to function as a filler-
theory, all of one
of her hands—her brother rotating,
 looks like 우
[석] two tunnels inspiring one entropic
 freightliner
to the statement, say the foreside
 of grip \

with the
option to split,
spilt
 or combine, be
 walked along. Be
 commercialized while the
 rest of the segments sag
under agreements'
covered logs: interventions
 of here
and there now,
voiceboxwork.
 Pines, the many-privates, winter in
 sun like somewhere

I've walked into
the found nature of.
 Its

warning, the beached light of a left-
heat source,
from reentering
Mammalia, a new angle on
 the homeboundward-
inch-
ing—a new dream
of
met glade:
 Wait

for the platform to
 rise from its
conspicuous slate,

the other time gone as
 if boarded, files
of Old,
honesty
 tagged by landing's need and
 approaching the new multiplier, wants of water,
 the switchback
 always possible to
 miss a second time.
 Stepping

 off into
 Scene

 spliced
by returning, heading for some
 principle of decantation
then,
Time as an orthodoxy—but one
 disobeys, inspiring a new
train

of behavior leaving
 for the other—loosened placements
 shortly
after
 Bodies corrugate
 into bleary portrayals
of cubes.
 to be
 possible as one looks
 on from a descendible
View:

over the shoulder, a zero-sum
flame along
a monthlong reason's slackened
tendon.
Commerce, continued, conflated
 livelihoods
 graveyards
with midday's remaining 국
[s]. Bangs

 nearing the cumbersome
 line of singed
eye
roving uncorked,
this corridor of
 preservation, the blue logic
 hard-pressing the return
key like hidden
 accelerant
 in my cup, darkening rows
 against the tissue of
 the foreground panning against the withholding—the
 most unnatural
 of the raw materials
 moving
into the full circle
for the first time, centering,
 We

have to hold
 this up to
 her notes—in a street-like
tide-wake walk
 against order, tending
 to the streamline, the peopled treelines,
go
바글바글바글
 the adverbial presence
of the hooded
 too interesting to populate
with vectors,
 자연
보호, the amusement of
 the word becoming
 a cylinder—the
 dirigible
we dreamed of being rescued
 from collides
against the inside
 of the screen.
It lifts
off
 the suture
evacuating

from white:
[dust]

at no time of day, in all
other light

This poem was drafted at the Berkeley Art Museum and Pacific Film Archive (BAMPFA) in early March 2022 during a private screening of Theresa Hak Kyung Cha's unproduced film-novel, *White Dust from Mongolia* (1980). Thank you to the archives for holding the space.

Thank you to Wendy's Subway and the March 2022 Quick and the Dead workshop participants for community and care. I viewed the footage again after the workshop, in April 2022, at the Whitney Biennial where Cha's work was exhibited, prompting many revisions to the poem.

Notes toward an echo-logy of
Mouth to Mouth
SAM CHA

ㅏ ㅑ ㅓ ㅕ ㅗㅛㅜㅠㅡ ㅣ is the conventional sequence of Korean vowels. Every Korean kid learns it, with the additional consonant ㅇ[1] (which, when placed before a vowel, has no sonic value) to convert the vowels into regular Korean syllables: 아야 어여오요우유으이 / a ya eo yeo o yo u yu eu i. But we learn this sequence as a series of vowel *pairs*: (아, 야) (어, 여) (오, 요) (우, 유) (으, 이) / (a, ya) (eo, yeo) (o, yo) (u, yu) (eu, i). In her 1975 video *Mouth to Mouth*, however, Theresa Hak Kyung Cha chooses to represent only (ㅏ, ㅑ) (ㅜ,) (ㅓ, ㅕ) (ㅡ,) (ㅗ, ㅛ). She's altered the sequence: if the conventional order of vowel pairs is ABCDE, the sequence in *Mouth to Mouth* (1975) is ADBEC. She omits ㅇ and as such, the vowels, unconstrained by syllable length, could potentially continue forever as raw sound—air forced through varying circumferences of throat and configurations of lips and tongue. And two vowels are missing: the ㅠ from D and the ㅣ from E, leaving ㅜ and ㅡ unpaired.

I don't have an explanation to offer. I don't have the space here to develop one.[2] All I have are fragments: observations, associations, speculations, myths, metaphor, puns. An exile's go-bag: items connected not by logic but by coincidence, accidental echo, sympathetic magic, homeopathy, poetry. But maybe that's fitting. Theresa must also have felt like this. Sometimes I imagine her imagining herself in the way that I sometimes imagine myself: in a dark room[3] full of echoes, whispering into them, until she or I can't tell which is voice and which is echo. There's a circularity there, of surrender and mastery, that is probably familiar to anyone who lives in

1 The letter, supposedly, is based on the shape of an open mouth. Which means that the open mouths of *Mouth to Mouth* are, in some sense, like representations of ㅇ: representations of representations of open mouths, soundless, but defining sound.

2 —like a photograph perhaps, in the cave of the darkroom, in the pharmacy of developer and stop bath and fixer?

3 (Which is history.)

language, whose experiences are filtered through a medium that both is and isn't theirs, but perhaps most to those of us who are asymmetrically bilingual, who gave up or had to give up or lost competencies in our first languages, who live in the city of one language built over the ruins of another. Who will die there.

In *Mouth to Mouth*, when the camera pans across the English words of the title, there is the sound of static: "endless drone, refueling itself. Autonomous. Self-generating."[4] When the camera pans across the Korean vowels, there is silence. When the mouth mouths the vowels, we hear only static, only drone, sometimes static unstatic, liquid, forming itself into suggestions of trickling, fluid and fluent, of black insect swarm, of snowfall. As if the vowels were overwritten.[5] As if the vowels were calling to us from afar, from a great distance. A whole universe in the way, to silence them.[6]

"Vowel" in Korean = 모음 and 홀소리. 모음 = Korean pronunciation of 母音, "mother sound." Also a homophone for "gathering" or "collection." The 홀 (pronounced, roughly, "hol") in 홀소리 means "solitary," but it exists in relation to 짝, "paired." A sound that's unpaired. Mothers lonely, unpaired: their sound, pared

4 Theresa Hak Kyung Cha, *Dictee* (Berkeley: University of California Press, 2001), 2.

5 Consider video as a text(ile). Imagine the clever little stylus/bobbin of the electron writing/ stitching light and dark into the thread of the scanlines. Imagine the scanlines unwoven from the image, something like 425 of them, either 30 or 60 times per second, depending on the display—12,750 or 25,500 scanlines per second—so that on a 24 inch 60hz display with a display ratio of 3:2, this would be equivalent to 19.97 inches per scan line—roughly 50 cm—1,2750 m/s of scanline—which means that the 478 seconds of *Mouth to Mouth* viewed on such a display can be visualized as a single line that is 6,094.5 kilometers long, nearly the radius of the Earth.

6 I read once that static, the kind you once often saw and heard on TV, but now mostly only hear on the radio, is caused by cosmic microwave background (CMB) radiation, which means that static is the echo of the Big Bang, the event that marks the beginning of our universe. But this event "echoes" in a way that goes beyond the usual definition of "echo," since the very medium through which this "echo" propagates is itself the continuance of the original event—it's as if a sound were to create a room and also the air in the room through which the sound moves, as well as the walls that the sound bounces off of, the observer in the room, and even the very substance of the consciousness of the observer—who then perceives the "echo." The observer is an echo of an echo of an echo of the echo they perceive.

What is the Big Bang for: Modern Korean history? The Korean diaspora? Theresa? For Korean history: if we're to judge by *Dictee*, perhaps Theresa would have said it was the Japanese annexation of Korea, and the overwriting of Korean language and culture. For the Korean diaspora: ditto. For Theresa in *Mouth to Mouth*? Perhaps the overwriting of the mother tongue by the static that accompanies English—which happens *because* she is in the US, which happens as part of the history of the Korean diaspora, which happens ultimately *because* of the Japanese annexation, in a way that is not dissimilar from the way that static is *because* of the Big Bang. Which she perceives as she does because she is the result of this history. A drowning in drone.

NOTES TOWARD AN ECHO-LOGY

down to animal intensity of vowels, the moan, the sigh, the crescendo hey-hey-HEY of anger.[7] But silenced.

The first Korean mother was a bear. A bear and a tiger wanted to be human. They asked a god, a colonizing sky-son come to build his city on a hill. His dictate: *Go to a deep cave. Stay for a hundred days. Eat nothing but mugwort, garlic.* The tiger couldn't hack it. But the bear bore it: loneliness, boredom, hunger, dark, pain. (What echoed there? Her vowels. Unheard by any other.) She emerged from the cave as from a womb: born again, woman. Near the beginning of *Dictee,* in the section entitled "Diseuse," Theresa seems to be giving us a version of this myth. The "she" whose viewpoint the narration follows is also trying to become human, or recognizable as human, by mimicking the speech that has been given to her. Her mimicking comes out as "bared noise."[8] The setting in which "she" mimics is figured as a womb, a place of waiting, of endurance, and of birth—"she" experiences the pressure to speak as a "contracting motion"[9] squeezing her skull; when at the end of the section the "she" feels herself poised to speak, "she" experiences it as a "delivery," the utterance "hers now," hers "bare."[10]

> Bared noise. Bear
> noise. To lay bare
> noise, to excavate.
> Reveal. Of a bear.
> To bear. To carry.
> To birth. To speak
> waking, reveille.

7 아 야 (ㅏ, ㅑ) (a, ya), which comes at the beginning both of the conventional sequence of vowels, and of Cha's modified sequence, is homophonous with a Korean exclamation of pain, roughly equivalent to "ow."

이(ㅣ) (e) is missing from *Mouth to Mouth.* 이 is the Korean pronunciation of 齒 (tooth). 이 is the Korean pronunciation of 理 (to order, to rule). The vowel that sounds like order is missing. The vowel that sounds like understanding is missing. Has no teeth. The vowel that looks like I is missing.

유(ㅠ) (yu) is missing from *Mouth to Mouth.* 유is the Korean pronunciation of 有 (to have, to exist). Also of 乳 (milk). Also of 由 (to cause). The vowel that sounds like presence is missing. No mother's milk. The vowel that sounds like you is missing.

ㅣ and ㅠ put together can sound like 이유 (理由): a reason; a cause. Illusory. Missing.

Pain remains. Unheard; seen, like an open mouth.

8 Cha, *Dictee*, 3.

9 Ibid, 4.

10 Ibid, 5.

M-OTHER-TONGUE-S
MEGAN SUNGYOON

어쩌면 발화와 비슷할 것이다. (어떤 것이든 모두.)[1]

<div>

 mother tongue other tongue

</div>

의 신화는 세습적인 것으로부터절대
 적이라고 믿는 것으로부터
 기인한다. 그 기저에는 폭력
 일 수도 자애일 수도 있는
 어머니가 있다 어머니
 왜 나를 낳으시고

나의 []에게 나의 []에게

살보다 적나라하고,

또

낳아지셨나요

문단 열기

mother(s) tongue(s)

What if mother's mother's tongue—not mother's mother tongue—is what mother is striving to speak, with many mothers' mothers' mother tongue(s) being a national language different from the later generation's mother tongue(s), for there was only a scarcity of nation during mothers' mothers' times and even the national language that maintains the same name is a faint, everchanging logic that is only concrete in myth, and to which mother (which one?) unfortunately subjects herself (which one?)

Do others' mother tongue(s) have the same pang to you? If not, what does that say about your mother, and if so, what do you know about others' mothers. Other mothers' tongue(s) are often the universal, the imperative, the veritable, as to you no mother is mother but your own, and this strangely renders all your mother's mothers your own, though mother is also an other, and that should keep mother's mother(s) at the same distance as others' mother(s). What does this matrilineage pass down, from tongue to tongue, that is *not* other to me?

1 Theresa Hak Kyung Cha, *Dictee* (Berkeley: University of California Press, 2001), 3. All translations and edits are mine. Explanations of the creative choices, if any, are in the footnotes.

MEGAN SUNGYOON

mother tongue
(하나. 하나만.)

안에서 속삭인다. 속삭인다. 안에는 발
화의 고통 말하는 것의 고통.
여전히 더 큰. 더 거대한 것은
말하지 않는 고통. 말하지 않는것. 말하
는 것의 고통에 대해 아무것도 말하지
않는다. 안에서 썩는다.
상처, 액체, 먼지. 부숴야 한다.
비워야 한 [2]

mother tongue
(한 번 더. 한 번 더로 될 것이다.)

그들의 구두법을 따를 것이다.
이에 맞추려고 기다린다. 그들의
것. 구두법. 자신이, 경계들이,
될 것이다. 흡수해. 쏟아내.
구두점을 움켜잡아. 마지막 숨.
[]에게 줘. []에게.
릴레이. 목소리. 배정. 인계해.
전달해. 전달.[3]

other tongue(s)

Once father tongue was. The dichotomy is precisely: TO MY MOTHER TO MY FATHER, conveniently yet unfathomably so. When mother (tongue or not) repels you and your ruinous sensitivity, can father (tongue and not) be the refuge, 시작한다 감지되지 못하도록, 거의 감지될 만큼? Not mastering the grammar of one's father tongue turns out to be a great sin also, because there's no such thing as daughter tongue. Hence everyone corrects her grammar. All her estranged and reunited fathers.

2 Ibid. Only this column contains unabridged, unedited translation

3 Ibid, 4. The singular subject in translation is not she but absence.

M-OTHER-TONGUE-S

mother tongue
(한 번만. 한 번이면 될 것이다.)

받아들인다. 정지를 받아들인다.
천천히. 짙음으로부터. 그 두께.
위로 향하는 무거운 동작으로부터. 전
달. 받아들인다. 천천히.
불러오기. 이제 항상. 존재하는
모든 시간 동안. 영원히. 그리고
언제나. 정지. 내뱉기. 이제 []의 것.
온전히 []의 것. 발화.[4]

other tongue (still)

Mother (maybe tongue) slaps me in the face. The third dimension is comforting because no one is to correct my nonlinearity in it. Never suffice; never satisfy a tongue. *Aren't you scared, that we will never be a whole in any language, and that we will remain two thirds in one language and one third in the other, but also: Do you know how many people would gladly give up one third of their native language to be able to speak that much?*

other('s) tongue
: why resurrect it all now

4 Ibid, 5. Among the many hers,
 hers concurrently now and bare.

a desert with tribes inhabiting it,
a full body clinging with multiplicities[5]

<div align="right">

M-OTHER-S-TONGUE-S-M-OTHER-S

</div>

One can't give up just one effectively at
third of their native language; point.
one needs to stop growing
in the language,

One has to be still growing when one stops growing.

<div align="right">

mot

</div>

she's suddenly an adult equal to

<div align="right">

remaining a
for the rest

One is perhaps

No more sentence to exile, Mother,

</div>

5 Gilles Deleuze and Félix Guattari, *A Thousand Plateaus: Capitalism and Schizophrenia*,
 trans. Brian Massumi (Minneapolis: University of Minnesota Press, 1987), 30.

6 Cha, 53

mother?
tongue?

Everyone so cries of mother [by the power of mother]
and mothers and mother tongue yet all three
had been disowned by everyone yes under
foreign occupation but mostly in exchange for
status. Suddenly came the time when mother is
rich and con- temporary and grown-up
estranged tongues hurry back home to
welcome mother who is a different mother
than the mother who has left. In any case
mother should be glad mother is now
influential mother can also be a matriarch!

-TONGUE-S-M-OTHER-S-TONGUE-S

 the two thirds

 When a child is ,

her;

 paradoxically she also
 never grows from that
 point on,

child at that age
of her life.

 a full adult in this language, but which one is this?

no black crows to mourn you.[6]

Neither takes you neither will take you Heaven nor Hell they fall too near you let them fall to each other you come back you come back to your one mother to your one father.[7]

7 Ibid.

Playing in the Dirt, Feeling Around in the Dark
IRENE HSU

It is hard to keep an eye on the subjects of Theresa Hak Kyung Cha's taped performance *Secret Spill* (1974). Watching the film is like feeling around in the dark: the difficulty is not so much that the subjects slip in and out of the frame, but that they shapeshift, are never quite as they seem. One moment we think we are looking at white stone shrouded in soil, and the next, at the rough surface of a canvas sack half-buried in earth.

Soil, stone, sack—this transformation is not sudden but slow, drawn out, and unstable. The lengthier piece in Cha's œuvre of avant-garde performance and cinema, *Secret Spill* strategically favors queasy sensory experimentation over neat linear development. It's like a prank, then, when Cha pulls not one but two plot twists over the course of a twenty-seven-minute plotless performance.[1] The first is built through textural clues—the punctured crease of stitched seams, the frayed ends of thread—suggesting that what appears to be weathered stone is in fact worn sack. When the video gives way to a view of the sack strung heavy around an overhanging branch, Cha goes in for the kill, putting the second development into play. Her slaughter is soft: hands feeling around the canvas, fingers probing the seams, before unzipping the sack and reaching in with hands cupped. Out from the split sack, earth spills onto earth, like a dirty joke: simultaneously sensual and funny, vulgar and nauseating.

1 *Secret Spill* was first performed by Cha in Berkeley, California, during the fall of 1974. It was taped as a video and originally meant to be viewed on a monitor.

Theresa Hak Kyung Cha, *Secret Spill*, 1974 (stills).

There are no speakers, no narrators framing the video. This silence intensifies how the event and erotics of sedimental/sentimental overflow escapes language, forbidding words long after the screen cuts to static and static cuts to black. Oscillating between visual disclosure and linguistic disavowal, the film's performance of secrecy is a powerful allegory for the ways in which colonial violence accumulates in the body as something unnamable generation after generation, (neo)colonial rule after colonial rule. As Cha writes in the opening pages of *Dictee* published eight years after the taping of *Secret Spill*:

> It murmurs inside. It murmurs. Inside is the pain of speech the pain to say. Larger still. Greater than is the pain not to say. To not say. Says nothing against the pain to speak.[2]

This is a powerful theme in Cha's work, which grapples with the suppression, loss, and mutation of language through the long legacies of Japanese colonialism and US occupation. "Pain to say" chafes against the "pain not to say," activating a critical question about taking up the language of the colonizer in the face of lingual dispossession: is this a means to an end, or merely a dead end?

The impossible task of speech poses yet another conundrum for the colonized. Bound to an (il)liberal structure privileging correct speech as demonstrative of subjecthood, the colonized is subjected to a system that grants or revokes legal rights, political freedoms, and social legitimacy accordingly. In *Black Skin, White Masks,* Frantz Fanon points out that through this system, the colonized is not only made speechless, but also fashioned into an object, "woven … out of a thousand details, anecdotes, and stories" to justify and reinforce political, economic, and social control.[3] Molded into a vessel mediating the sensations and projections of the colonizer, the colonized body undergoes a process akin to sediment build-up over time—a deep time, a deeply violent time, that outdates the nominal beginnings and ends of occupations.

Stuffed and spilling over with dirt, the leaden sack in *Secret Spill* embodies this abject state of objecthood, one that is peculiarly geologic. Silent, heavy, inert, the sack recalls the lithic landscape that spans the cover of *Dictee*. Like an ache, it strains against itself, a visual echo to *Dictee*'s cover of timeworn relics, sedimentary

2 Theresa Hak Kyung Cha, *Dictee* (Berkeley: University of California Press, 2001), 3.

3 Frantz Fanon, *Black Skin, White Masks*, trans. Richard Philcox (New York: Grove Press, 2008), 91.

objects composed of fossilized residue from another time. But while the grammar of the colonizer equates "it"—what is nonhuman, nonspeaking—with an object to be dominated, Cha's visual and tactile performances intimate a liveliness to nonhuman matter, one that is not easy to bear in *Secret Spill*.

For the motion-sick viewer, there is no way to watch the video except with eyes slightly unfocused, like getting through the day with a bad migraine. Soil, stone, sack—it is no accident that over half of the film dwells on shapeshifting matter through close-ups so shaky they nauseate. The way a curious creature makes an improbable home out of debris, the camera pokes around in the dirt, nosing tufts of weed, root, and string. This project of homemaking is no neoliberal practice of consumptive self-care. After all, there is nothing easy about hospitality when it involves making do amid inhospitable conditions. Rather, making home is a process of painstaking transformation, a test of patience that is simultaneously playful and demanding, cozy and claustrophobic.

As the inquisitive camera probes, shifting in and out of focus, the video reminds us that seeing *out of focus* is hardly the same as being out of it. To be out of it is to be elsewhere, while the world passes you by; to see out of focus is to be swept up in the world, in all its horror and glory, but with a soft touch. Mired in the mud of the world, *Secret Spill* is very much invested in the soft touch of the latter. Playing in the dirt necessitates a shift from sight to touch, and it is this metamorphosis of the visual into the tactile that constitutes the video's haptic experience. In approaching the abject, hapticality becomes a key aesthetic strategy, one that compels us to attend to how curiosity and dread build up in our bodies as somatic excess. This is the tension Cha sets up: we are at once the active subjects of the film, scooping soil like a child playing in a garden, and the viewers subjected to the frame, sitting tight with churning stomachs.[4]

4 In thinking through the geological in *Secret Spill*, I want to thank Sooyoung Moon, who moderated a screening of Cha's films I attended in fall of 2021, organized by OHYUNG. Sooyoung spoke about the uncanny experience of watching Cha's excavation performance, and recalling the time they spent in Seoul as a child, cautioned by their grandmother about undetonated and unrecorded landmines in the mountains where they played. Thank you, too, to Seunghwa Madeleine Han, who pointed me to Eleana J. Kim's book, *Making Peace with Nature: Ecological Encounters along the Korean DMZ* (2022), in which Kim discusses the socio-ecological landscape of the DMZ, and the situational knowledge of locals who have learned to live with landmines as a way of reclaiming their experiences with war and their relationship to land. Finally, words do not do justice, but thank you to Anthony Veasna So, who spoke with me in August 2020 about an essay he had hoped to write about Theresa, fashion, and style; and whose passing that December has since led me back to Theresa's work as a guide for the living to commune—once more, again and again—with the dead.

If the cloth lump is a symbol for the sum of affective experiences cemented in the body through colonial violence, then Cha's video performs curiosity as a tool to abide by the self made strange, the home of a body made unhomely. In grappling with the density of ugly feelings materialized/metabolized in the body, Anne Cheng's insights on repair to racialized objecthood are instructive. As she writes in *Ornamentalism*, "[S]elf-regard delineates an approach back toward the self as a collection of lost objects. Having been made stranger to oneself by unimaginable brutality means that one must reapproach the self as a stranger."[5] By invoking the body as an archive, Cheng highlights the felt sense that exists below the threshold of colonial imagination and knowledge production. And by calling upon self-regard as a practice of repair, Cheng highlights the lived experiences that escape the archive, the master's house.[6] It makes possible a reading of *Secret Spill* as a performance that rebuilds the home of oneself, through the intimate destruction of falling apart—using one's bare hands to pry oneself loose from what Fanon has called colonialism's "arsenal of complexes," so as to feel out and forge a world according to terms that do not demand alienation from one's lived experiences.[7]

It is apt that Fanon metaphorizes colonialism's psycho-affective dimensions through the arsenal, through military technology targeting body and land. Ultimately the body's relationship to land bears the scars of imperial warfare, which manifests in ideology and infrastructure, ecology economy, attrition and aggression. *Secret Spill* makes perceptible an affective structure emergent from military infrastructure–tethering those exiled from a divided and occupied homeland, to those making their livelihoods in land intended for waste by herbicidal warfare, uncleared explosives, and militarized borders. When dirt spills onto dirt, the performance of excavation in *Secret Spill* yokes the abjection of the body to the abjection of the earth. Decomposing remains, fossilized inheritances, substance broken down–an interior in ruins yearns, hearkens to the ruins that lie beyond.

"The militant therefore is one who works," as Fanon has said about the project of decolonization. "To work means to work towards the death of the colonist."[8] The work that the militant takes up–with hardened hands, their muscles, their whole

5 Anne Anlin Cheng, *Ornamentalism* (New York: Oxford University Press, 2019), 154–55.

6 Audre Lorde, *The Master's Tools Will Never Dismantle the Master's House* (New York: Penguin Modern, 2017), 19; Jacques Derrida, *Archive Fever: A Freudian Impression*, trans. Eric Prenowitz (Chicago: University of Chicago Press, 2017).

7 Fanon, *Black Skin, White Masks*, 30.

8 Fanon, 44.

Theresa Hak Kyung Cha, *Secret Spill*, 1974 (still).

heart–is as much a psycho-affective process as it is physical and material, in search of a way "back toward the self." And, as the arduous object study of *Secret Spill* suggests, the way back demands no less than an excavation of the decomposition within. No less than sifting the rubble and searching the ruins beyond. No less than digging deep, feeling around in the dark.

Easy as they come, gentle as can be.

Spill Out
MARIAN CHUDNOVSKY
AND FLORENCE LI

The slanted door opens. A warm breeze shuffles through. His tense shoulders soften as each foot steps in front of the other. His hand no longer clenches, his fingers move freely, and his skin runs smooth. His footsteps remain soft. A slow sigh ripples. His shirt's blue cotton sleeve brushes gently against his wrist. A green vase of flowers rests atop a wooden table. The stems curve then droop. The red tulips smile. He settles down at his place. There is a white tablecloth. There are eight chairs. He turns to look around, wants to know what's for dinner. He is impatient. The sun spills forth and casts a hazy glow. A low refrigerator hum drones on, the cars whisper abruptly, quietening as they drive past. The dust dances in the light. His fingers drum the table. They twinkle. He sighs knowingly. He glances at his watch. Late again? I inhale the broadcast.

"I heard the rain does not erase the blood fallen on the ground. I heard from the adults, the blood stains still. Year after year it rained. The stone pavement stained where you fell still remains dark."[1]

Sunday night. She sits on the sofa waiting for the clock to turn. She takes the phone and dials. Punching numbers into a keypad. What a spread awaits. How many days? How many years? How many months? I have lost count and I don't want to know. What is grief if not the attempt to breathe life into memory?

How do I hold you, my dead?

We were in the park. I was grasping onto a blunt blade of grass. Taking turns standing watch, I kept averting my gaze to ward off onlookers. As I licked my

1 Theresa Hak Kyung Cha, *Dictee* (Berkeley: University of California Press, 2001), 82.

finger, the wind wavered. The wooden urn creaked open. Burying under my nail, the ash affixed itself. I swallowed. What does it mean for me to carry a drop of you inside of me? I think of you tumbling through my body, sliding down each intestine, memory, crevice. Do you turn each over like a stone? A trace remains forever imprinted somewhere in my bloodstream.

There is a theory of creation often cited in Kabbalah, Tsimtsum, which propounds that the universe was created through God's withdrawal. A kind of exile, leaving behind infinite light and space for the universe. The light is the condition for our existence, and yet, there is a haunting in the wake of creation. We are left wondering, always, how to repair the world. Where God is. What to do with all this light.

Breaking into grief like I am breaking into new shoes. There was no burial, just a return to the elements. When I step onto the ground, there is minimal buoyancy. I search for resonance, I know you are all around, but my footsteps find only the damp.

I think of Secret Spill, *the violence of grabbing and ripping apart, and its necessity. The earth, overturned as if in a burial mound. A shadow of what was to come. I think of* Secret Spill *and I think of the day after you died. I ran out into the street and clawed at the wet dirt surrounding the tree in front of my apartment building. I dug and dug, not yet crying. I remember hoping I would find you there, waiting in the mud, playing with the worms.*

I still wait for you in the mud.

Are we in the endless voyage now?
Can you tell me if I am on the conveyor belt?
Do you see me?
Lately I've been writing you with a worm's eye view.
Can you break this in for me?

Define martyr. Write for me what it is to save thousands, their stories held on the back of our imagination of a boy with a scrape. When he saves thousands, they hold him with them always, an unintentional and inescapable lifeline. As if somehow his death was worth it, divinely ordained.

They climb through the spring. They trudge through the mud. She tugs down at her backpack straps which leaves an indent on her shoulders. He is convinced he is following the correct directions. They settle at camp, dusk brings the bugs. They re-

SPILL OUT

main bothered and water leeches out. The damp night seeps into the tent. It gives way to a dull hum.

When I write you I carry your bones. Sometimes they are so heavy.

Do you still like to take long naps?
Where do you swim?
Where do you do your grocery shopping?
Do you still bake?
What TV are you watching?

I hold you with me, but every day your freckles fade more and more from my memory. I miss you, even as you drift towards an apparition. I wonder, always, what to do with your light. It was never mine to begin with.

A smile spreads across his face. I want to compare it to the sun breaking across the clouds, but I fear cliché. Children can talk in monologues but I know you are always responding. They tug on your clenched fingers and I place them on your lap. They crawl up and down and accidentally thwack your nose. You just chortle. You gaze lovingly at your family. Laced with love and curiosity, you always enjoyed it.

Year after year it rains.

He twiddles his thumbs because she is late again. She arrives in a flurry. He rolls his eyes and their embrace is enveloping. The walls stretch high and the sun washes aglow. There is quiet but, nonetheless, small giggles bubble up. He lets a call slide away. They amble through the space and point at the art periodically. They see sculptures made from strings. They create a threshold and a shape slowly emerges. They swallow time and it sits glowing cheerfully in the belly. Their conversation is an excited stream. Eventually, they will have to leave. They bicker and furtively agree over food. Hot bowls of onion soup to numb the cold! He sends her home first. Always a big brother first.

You will stay alive with me today and I will allow myself to believe, for a moment, that you too have grown up. Maybe I write to you, after a long while. You respond and we are here, in the future, together. Just like the day you reminded me that I had always known how to peddle. Held my handlebars and whispered, "good job." Walked alongside me, even though we could both hear the ice cream truck. Held my handlebars till I asked you to let go. Till I was off on my own.

The ocean washes out. As if there is a galaxy awaiting. But what do the waves contain? I want to know but am afraid I might spill out. And you are here, buoyant and resplendent. The smile breaks and the ashes blow away. This is a neat reminder. I exhale the broadcast.

What if you still held me while I practiced?

I write you daily, from here. I write through to you. A billow of memory splits like smoke and a tunnel chutes through. I write through me, my hand extended. Are you seated? Can you see my still reach? We crest gently, and I wonder if your ears still fold like butter. If your fingers still clench. I can feel your arrivals, too. Your laugh still trails, silently.

The stone pavement stained where you fell still remains dark.

The rust creaks at the door hinge. Metal oxidizes over time, it becomes brittle. We, too, oxidize and creak. But the creek runs pebbles smooth, and they tumble tumble along a bed. I don't think this will ever be polished. I will always feel a molten compression. Writing you creates an open valve, cools the wet flame, and encourages me to swallow slowly. Your ash trails in my body. Slinking, careening, gliding.

We glide across the wind together. Over the Unisphere, towards the ocean, maybe we'll head to Rockaway. Dream big and go to Riverhead, say hi to grandma. We will let the wind buoy us and there will be nothing to do but laugh. Let it tickle.

In the ocean at last. Will I see you later? I write you always. You write me always. From here. From there. Awaiting.

SPILL OUT

On Stones
JUWON JUN

Abstract is their verb. As in, they abstract her humanity. When her life, just as mine, is material. Start foremost from our bodies, from a particular hunger or feeling. As in, what will we eat today. As in, there is a pain in my knee. As in, you've grown so unfamiliar. Have you grown unfamiliar?

She narrates her childhood to me. This is a familiar scene. We sit facing each other at the dining table:

She was born during colonial rule. To speak your own tongue was forbidden. She remembers pissing herself in the classroom because the teacher forbade her from using the bathroom. They hit her until her limbs burst. There is no space for reason, other than the simple fact that her body was there, ready to be disciplined. Palms and wooden sticks: these are the materials of her memory. She is eleven here. Her name is Kurimoto, a surname given by the Japanese empire.

She sings a song for me. This is not our language. Her singing is automatic: a dicteé by tongues. Hers reels off the lyrics effortlessly. The melody sticks to the tongue's surface like a pest, unwilling to be shaken off.

She names Baengnyeongdo, an island once a part of Hwanghaedo, a province of farmers and agricultural workers in the North. Now, a densely militarized zone of Incheon for its proximity to the North. In Baengnyeongdo, seaweed, kelp, and abalone are found in abundance. Ocean fauna and egrets. Baengyneongdo is our homeland, she says. That Hwanghaedo.

Before June 25th eclipsed the peninsula, she would cross through Kuwolsan to distant towns and back. A restless child on her feet, she practiced the possibility of

these years with her body, fresh from emancipation. I imagine the dirt beneath her feet, lush green that brushed against her ankles.

When the war came, she left her hometown with the seventy families in her village. Her days were punctuated by its composition—bombs, rifles, ships, tanks, American soldiers, and bullets—her ears remember their sounds, her skin their textures, and her eyes their sheen and violence. She would ask for a bowl of rice from soldiers nearby. They would ask her to sing them a song. So she would sing for the soldiers and earn a single bowl back to the families. Her mother would make porridge from that bowl. They would each take a spoonful. She is fourteen.

She walks the bare land with her mother. Stones tumble at their feet. She asks her mother why there are so many of them, the round, tumbling stones. They cover every surface of this land. *Foolish child, these are skulls.*

How do you walk the land?
How have we become your stones?

Trauma confuses the tongue. Words spill out of her each time with such force (her voice becomes dizzying, rearranges me) they become gravel.

Trauma takes shape in circulation, tracing back to her first memory, objects named again then once more, until nothing remains but rubble. A trace of what used to be. A retelling or recirculation that begs to be concluded. She recites in this debris. Her recollections unmake me.

She finishes this scene like it never began.

ON STONES

In class I am asked to dance like a heavy stone. I picture the skulls tumbling on the land she once walked. I curl up on the studio floor. I let my body roll across the floor in slow motion. From the shoulder to the shoulder blade to the surface of my back, the floor travels down my spine. I am upside down. I cannot get the image out of my head, so I enact her stones. Sometimes objects find themselves in our bodies, how memories do. Language finds a way into a moving body. It confronts a memory that is not mine. Then a feather.

Abstract is my noun, a violence done unto you, hardened by the cruel passing of time. Like your stones and the traces of mine. Yet, like all expressions, abstraction cannot forgo the material—it mourns its loss even louder through the obscuring.

Your stones move freely. Some days I envy their shape with a particular shame. Your children carry them too. Each day they scrape against our inners and soften their edges. They roll around and push through our skin, insist that we are porous. We no longer recognize the form. They polish and harden into a reminder. Only a reminder.

My body mourns your stones. This is not an abstraction. Their time pushes past you and your mothers. Your stones ask me to remember their traces, ask me to remember you so.

I do not write of exceptions. I do not desire to become an exception. That would mean to have been abstracted from your history: your collection of stones.

This body is not an exception. There must be no distinction from this body to stone. From yours to mine.

I once observed you, bent over the kitchen sink. Your body curled forward. Fine creases formed at every fold, from your neck to your fingers, your knees, and ankles. You wore a black dress that draped down to your swollen ankles over your figure, hardly a woman's body. Black polyester with prints of bright pink and green imitating flowers. You were a mountain, burnt to its surface, exposing its dark earth, miraculous flowers decorating its bare skin.

I build you out of the stones you gave me. I stack them into a mound. What does that make you? A mountain, or a grave. A young girl. I could stack them into a body, not yours nor mine.

I write you as a reminder. I recite only these words:

Let us be undone from this fantasy.
Let me be undone from theirs.
Let me be unrecognizable to this self.
Let these stones unmake this body.
Let these stones unmake them.

ON STONES

CONTRIBUTORS

SAM CHA was born in Korea and earned his MFA at UMass Boston. A Push-cart Prize winner, Cha's poems, essays, and cross-genre works have been published widely. He is the author of *American Carnage* (Portable Press @ Yo-Yo Labs, 2018) and *The Yellow Book* ([PANK], 2020).

MARIAN CHUDNOVSKY is an archivist and art worker from Queens, New York. She is the Librarian at Wendy's Subway and works at other cultural organizations such as the Center for Art, Research and Alliances (CARA). Her work focuses on expanded ideas of memory, upkeep, and documentation.

JESSE CHUN is an artist living and working between New York and Seoul. Chun's work has been presented internationally at the 12th Seoul Mediacity Biennale; SculptureCenter, New York; The Drawing Center, New York; Ballroom Marfa, Texas; Museum of Contemporary Art Toronto; Nam June Paik Art Center, South Korea; and Whitechapel Gallery, London, among others. Chun's work is in the collections of Seoul Museum of Art; Museum of Modern Art Library; and KADIST, among others.

UNA CHUNG is Professor of Literature and Media at Sarah Lawrence College. She received her PhD from the Graduate Center, City University of New York. She has published essays in *Beyond Biopolitics: Essays on the Governance of Life and Death* (Duke University Press, 2011), *Journal for Comparative Philosophy*, and *Women's Studies Quarterly.*

ANTON HAUGEN is a writer from Silicon Valley. He has previously published work with Rhizome, the Asia Art Archive in America, *Codette*, and *Arachne*, and currently works as an editor for the arts, politics, and culture journal *The Reservoir*, published by Woodbine and Autonomedia. He is currently working on a novel.

IRENE HSU is a writer and researcher based in Brooklyn. They are working on a chapbook that dismembers the US war machine through a poetics of soil, salt, sand, and islands. Their writings and conversations are homed in the Asian American Writers' Workshop, *Brooklyn Rail*, *Fruit Journal*, and Mixed Rice Zines, among others. At their day job with CAAAV: Organizing Asian Communities, they build storytelling and media strategy to fight real estate propaganda and grow the leadership of working-class and immigrant tenants.

SANJANA (SUNNY) IYER is a curator and art worker based in New York City. She is the Program Director at Wendy's Subway, which she joined in 2017. She is also the Fairs & Editions Coordinator at Printed Matter, and serves as the shop steward of the union.

VALENTINA JAGER is a visual artist, writer, and translator. She earned a PhD in Creative Writing in Spanish from the University of Houston and now lives with her cats on an island surrounded by refineries and mutant fish in the Gulf of Mexico.

JUWON JUN is an artist based in New York. She has shown work with Gyeonggi Museum of Modern Art, RISD Museum, Brooklyn Women's Film Festival, Les Femmes Underground Film Festival, Anthology Film Archives, Boston Center for the Arts, CINEMQ, and more. She is an Associate Editor at Wendy's Subway. Her writing has appeared in *offshoot*.

YOUBIN KANG is a postdoctoral fellow at the School of Industrial and Labor Relations at Cornell University. Kang received a PhD from the University of Wisconsin-Madison, and holds a BA from Brown University and a BFA from the Rhode Island School of Design. Kang's work has been supported by the National Science Foundation and the Social Science Research Council, and is in the process of being developed as a book project, *Underground Labor and the Politics of Circuits.*

EUNSONG KIM is an associate professor in the Department of English at Northeastern University. She is the author of *The Politics of Collecting: Race & the Aestheticization of Property* (Duke University Press, 2024), *gospel of regicide* (Noemi Press, 2017), and translated Kim Eon Hee's *Have You Been Feeling Blue These Days?* with Sung Gi Kim (Noemi Press, 2019). She's the recipient of the Ford Foundation Fellowship, Yale's Poynter Fellowship, and an Andy Warhol Art Writers Grant. In 2021 she co-founded *offshoot*, an arts space for transnational activist conversations.

YOUNA KWAK is a poet, literary translator, and teacher, born in Seoul and based in Southern California. She is the author of a poetry collection, *sur vie* (Fathom Books, 2020), and two books of translation, François Bon's experimental novel *Daewoo* and *Gardeners*, a short story collection by Véronique Bizot (Diálogos Press, 2020 and 2017).

JENNIFER KWON DOBBS is the author of *Interrogation Room* (White Pine Press, 2018); *Paper Pavilion* (White Pine, 2007), winner of the White Pine Press Poetry Prize; and the chapbooks *Notes from a Missing Person* (Essay Press, 2015) and *Necro Citizens* (German/English edition, hochroth Verlag, 2019). She also co-translates Sámi poetry with poet-scholar Johanna Domokos, including, most recently, Niillas Holmberg's *Juolgevuođđu as Underfoot* (White Pine Press, 2022). Currently, she is Professor of English at St. Olaf College and senior poetry editor at *AGNI*.

ANDREW YONG HOON LEE is an artist working with performance, music, sound, drawing, text, and video, exploring themes of memory, movement, and distance. Recent exhibitions include Staatliche Kunsthalle, Baden-Baden; Haul Gallery, Brooklyn; Parent Gallery, Brooklyn; Catriona Jeffries, Vancouver; Friedman Gallery, New York; New York Artist Residency Foundation; Achtung Cinema, Paris; Kinoskop International Analog Film Festival, Belgrade; Mono No Aware Festival of Cinema-Arts, Brooklyn; and the Vancouver Art Gallery.

JENNIFER GAYOUNG LEE splits her time between New York City and the Bay Area, where she is pursuing a PhD in Modern Thought and Literature at Stanford University. Her writing on Theresa Hak Kyung Cha has also appeared in *Journal of Asian American Studies*.

SUJIN LEE is an artist working with language in text, performance, and moving images. Her work has been presented in South Korea at MMCA Seoul Film & Video and ARKO Art Center, and in New York at The Bronx Museum of the Arts, Queens Museum, and Brooklyn Museum. She was awarded artist residencies from Millay Arts, the Blue Mountain Center, I-Park, Newark Museum, Artkommunalka, among others. She has received several fellowships and awards, including the A.I.R. Gallery Fellowship (2012) and Wumin Art Award (2018).

FLORENCE (FLO) LI is a New York-based artist, writer, and art worker from Hong Kong. She is the Program Coordinator at Wendy's Subway and works at Lehmann Maupin Gallery. She is interested in using art and media as a tool to explore memory, the complexities of belonging, and the fluidity of home.

SERUBIRI MOSES is an author and curator based in New York City. He is the author of several book chapters translated into five languages, and is the editor of *Forces of Art: Perspectives from a Changing World* (Valiz, 2021).

He currently serves as faculty in Art History at Hunter College, CUNY, and has previously held teaching positions at New York University; Center for Curatorial Studies, Bard College; New Centre for Research and Practice; Dark Study; and Digital Earth Fellowship. He has organized exhibitions at MoMA PS1, Long Island City; Kunst-Werke Institute for Contemporary Art, Berlin; and the Hessel Museum, Bard College, New York. He serves on the editorial team of *e-flux journal*.

JED MUNSON wrote the poetry chapbooks *Newsflash Under Fire*, *Over the Shoulder* (UDP, 2021), *Silts* (above/ground, 2022), *Minesweeper* (NMP/DIA-GRAM, 2023), and *Portrait with Parkinson's* (Oxeye, 2023). He is the author, most recently, of *Commentary on the Birds* (Rescue Press, 2023).

YVES TONG NGUYEN is a Vietnamese queer disabled abolitionist organizer and cultural worker currently organizing with Red Canary Song and Survived & Punished NY, and formerly with Free Them All 4 Public Health. They are personally concerned with supporting survivors of all forms of violence through organizing and informal community support. They have experience supporting sex workers, migrant workers, and survivors of gender-based violence, particularly criminalized survivors of abuse.

WIRUNWAN VICTORIA PITAKTONG works with translation in its varied forms and manifestations, fumbling around written and spoken words in search for resonances across territorial waters. In 2020, she co-founded the Namkheun Collective. Since 2019, Pitaktong has also been a member of the artistic collective Speedy Grandma in Bangkok, which has curated exhibitions, organized film screenings, a flea market, and an alternative school, among other activities.

BRANDON SHIMODA is a yonsei poet/writer, and the author of several books, including *The Grave on the Wall* (City Lights, 2019), which received the PEN Open Book Award, and *Hydra Medusa* (Nightboat Books, 2023).

CATERINA STAMOU is a poet, researcher, and curator living in Athens, Greece. She wrote her MA thesis on the multiplicity of the female self in Theresa Hak Kyung Cha's *Dictee*. She was the 2022 recipient of the Jack Collom Scholarship for Writing and Ecology at the Jack Kerouac School of Disembodied Poetics' Summer Writing Program and a 2023 Book Art Research Fellow at Center for Book Arts, New York. She is a PhD candidate in the Department of English at

the National and Kapodistrian University of Athens. She has been awarded the Stavros Niarchos Foundation Artist Fellowship by Artworks in the field of curating (2022).

MEGAN SUNGYOON translates between languages and across genres. The translator of Seo Jung Hak's *The Cheapest France in Town* (World Poetry Books, 2023), Sungyoon has works published in *128 Lit Digital*, *Copper Nickel*, *Asymptote*, *Columbia Journal*, *SAND Journal*, and *The Margins*, among others.

TELINE TRẦN is a writer from Orange, California, or Gabrieleño/Tongva land. They write about home and interstitial faith via several mediums such as fiction, poetry, film, and ultimately the browser. Teline works as the Membership and Community Engagement Coordinator at Wendy's Subway, where they were a Fellow in 2020. They also work as the Development Coordinator at Mekong NYC, a Southeast Asian grassroots organization in the Bronx. Teline's first poetry chapbook is *Ad Học* (2023).

RACHEL VALINSKY is a writer, translator, and editor. She is a co-founder and the Artistic Director at Wendy's Subway, and currently serves as the Managing Editor at the Center for Art, Research and Alliances (CARA) in New York. Rachel holds an MPhil in Art History from the Graduate Center, City University of New York, and teaches courses in art history, performance studies, art writing, and critical thinking at New York University and The New School.

SOYOUNG YOON is assistant professor and program director of art history and visual studies at the Department of the Arts, Eugene Lang College of Liberal Arts, The New School. Yoon received her PhD from Stanford University and holds a BA from Seoul National University. She was a Faculty at the Whitney Museum of American Art's Independent Study Program from 2012 to 2023. Yoon's research focuses on politics of mobility and rhetorics of testimony, witnessing, and storytelling in the moving image. Yoon was a recipient of a Hauser & Wirth Research Fellowship for her work on the artist Theresa Hak Kyung Cha in 2019–20, and a contributing author on the work of Cha for the *2022 Whitney Biennial: Quiet As It's Kept*. Yoon is currently at work on two book projects: *Walkie Talkie* and *TV Buddhas*.

IMAGES CREDITS

Pages 72, 95, 99–100: Theresa Hak Kyung Cha, *Exilée and Temps Morts: Selected Works* (University of California Press, 2022). Courtesy of University of California, Berkeley Art Museum and Pacific Film Archive; Gift of the Theresa Hak Kyung Cha Memorial Foundation.

Page 94: Theresa Hak Kyung Cha, *Exilée and Temps Morts: Selected Works* (University of California Press, 2009). Courtesy of University of California, Berkeley Art Museum and Pacific Film Archive; Gift of the Theresa Hak Kyung Cha Memorial Foundation.

Page 188*: Theresa Hak Kyung Cha: *A Ble Wail*, performed at Worth Ryder Gallery, University of California, Berkeley, 1975. 28 black-and-white photographs and typewritten text on paper; sheet: 11.5 × 8.25 in. Courtesy of University of California, Berkeley Art Museum and Pacific Film Archive; Gift of the Theresa Hak Kyung Cha Memorial Foundation.
*This work is incorrectly dated 1978 (rather than 1975) in the caption on p. 188.

Pages 189, 198–200: Photos by Mengwen Cao.

Page 215: *La Passion de Jeanne d'Arc*, a film by Carl Theodor Dreyer © 1928 Gaumont.

Pages 262–63, 267: Theresa Hak Kyung Cha, *Secret Spill*, 1974. Video, 27 min., b&w, sound. Collection of the University of California, Berkeley Art Museum and Pacific Film Archive, Gift of the Theresa Hak Kyung Cha Memorial Foundation. Copyright: Regents of the University of California. Courtesy of Electronic Arts Intermix (EAI), New York.

**Erratum: Due to an error in production, the image credits on p. 292 of this volume are inaccurate. The correct image credits have been reproduced here. Please refer to this insert for accurate caption and credit information.

IMAGES CREDITS**

Cover: Theresa Hak Kyung Cha, *Other Things Seen, Other Things Heard* (photographs), 1978. 12 black-and-white photographs; 8 × 10 in.Courtesy of University of California, Berkeley Art Museum and Pacific Film Archive; Gift of the Theresa Hak Kyung Cha Memorial Foundation.

Pages 30, 58, 118, 140, 212, 258: Andrew Yong Hoon Lee, *Liquids and Phonemes*, 2023. Courtesy of the artist.

Pages 44–45, 52: Courtesy of Jennifer Kwon Dobbs.

Page 47: Courtesy of the Korean War Children's Memorial, Bellingham, Washington.

Page 49: Courtesy of the Phillips Hale Collection, Boston Public Library, Massachusetts.

Pages 62, 64–66, 76, 84–87, 92, 96–97: Theresa Hak Kyung Cha, *Dictee* (University of California Press, 2001). Courtesy of University of California, Berkeley Art Museum and Pacific Film Archive; Gift of the Theresa Hak Kyung Cha Memorial Foundation.

Pages 90–91: Theresa Hak Kyung Cha, *Dictee* (Tanam Press, 1982). Courtesy of University of California, Berkeley Art Museum and Pacific Film Archive; Gift of the Theresa Hak Kyung Cha Memorial Foundation.

Pages 67*: Theresa Hak Kyung Cha, *Mouth to Mouth*, c. 1975. Letraset on board; 20 × 30 in. Courtesy of University of California, Berkeley Art Museum and Pacific Film Archive; Gift of the Theresa Hak Kyung Cha Memorial Foundation.
This work is incorrectly dated 1975 (rather than c. 1975) in the caption on p. 67.

Pages 68, 171, 223: Theresa Hak Kyung Cha, *Mouth to Mouth*, 1975. Video, 8 min., b&w, sound. Collection of the University of California, Berkeley Art Museum and Pacific Film Archive, Gift of the Theresa Hak Kyung Cha Memorial Foundation. Copyright: Regents of the University of California. Courtesy of Electronic Arts Intermix (EAI), New York.

Pages 70–71: Theresa Hak Kyung Cha, *Exilée* (photographs), 1980. 16 black-and-white photographs; 8 × 10 in. Courtesy of University of California, Berkeley Art Museum and Pacific Film Archive; Gift of the Theresa Hak Kyung Cha Memorial Foundation.

ACKNOWLEDGMENTS

She Follows No Progression: A Theresa Hak Kyung Cha Reader is published on the occasion of the 2022 program, The Quick and the Dead: Theresa Hak Kyung Cha Edition. The Quick and the Dead is a yearlong, multiphase project that highlights the life, work, and legacy of a deceased writer by bridging their work to that of contemporary practitioners. In its third year, the program focused on Theresa Hak Kyung Cha.

The Quick and the Dead was supported, in part, by Humanities New York with support from the National Endowment from the Humanities, and the New York State Council on the Arts with the support of the Office of the Governor and the New York State Legislature.

Special thanks to Mary-Kim Arnold, Alexander Chee, and Laura Hyun Yi Kang for sharing their work and reflections as part of The Quick and the Dead seminars, as well as to all the seminar participants. We also wish to thank Laura Graziano and Stephanie Cannizzo at the University of California, Berkeley Art Museum and Pacific Film Archive (BAMPFA); Rebecca Cleman, Jooyoung Friedman-Buchanan, and Charlotte Strange at Electronic Arts Intermix; Megan Heuer at the Whitney Museum of American Art; Margaret Stern (formerly) at Printed Matter; and Tyler Maxin at Spectacle Theater.

The Quick and the Dead Publication Series #2
First Edition, 2024
Edition of 1,500
Edited by Juwon Jun and Rachel Valinsky
Proofread by Corinne Butta

Cover: Theresa Hak Kyung Cha, *Other Things Seen, Other Things Heard* (photographs), 1978. Black-and-white photographs, 8 × 10 inches.

Foreword by Sanjana Iyer
Contributions by Sam Cha, Marian Chudnovsky, Jesse Chun, Una Chung, Anton Haugen, Irene Hsu, Valentina Jager, Juwon Jun, Youbin Kang, Eunsong Kim, Youna Kwak, Jennifer Kwon Dobbs, Andrew Yong Hoon Lee, Jennifer Gayoung Lee, Sujin Lee, Florence Li, Serubiri Moses, Jed Munson, Yves Tong Nguyen, Wirunwan Victoria Pitaktong, Brandon Shimoda, Caterina Stamou, Megan Sungyoon, Teline Tran, and Soyoung Yoon.

Designed by Claire Zhang
Design Assistance by Patrick Yang MacDonald
Image Retouching by Michel Sixou
Typeset in GT Sectra and ABC Favorit
Printed at Jelgavas Tipogrāfija, Latvia

ISBN: 979-8-9863375-8-6
LCCN: 2024931663

Published by Wendy's Subway
379 Bushwick Avenue
Brooklyn, NY 11206
wendyssubway.com

Wendy's Subway is a non-profit reading room, writing space, and independent publisher located in Brooklyn.